ARCHIVES DE NUIT

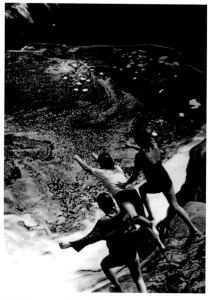

HELMUT NEWTON

ARCHIVES DE NUIT

WITH A FOREWORD BY JOSÉ ALVAREZ

SCHIRMER ART BOOKS

Thanks to Ralph Gibson

FOREWORD

Over the last thirty years, Helmut Newton has established himself as one of the principal photographers of our time.

The enthusiasm with which we awaited each of his new publications during the 1960s and 1970s is still unforgettable. Even then, he was presenting an image of our society through the medium of his numerous fashion reports, and astonishing us with the breadth of his imagination and his incomparable mastery of technique. He built up week by week what quickly became known as 'Newton's universe', pursuing his ascent towards the apex of the unconscious – the rediscovery of childhood. What is this universe all about, in which our obsessions condense and which we often too hastily – out of fear, or simply out of blindness – seek to evade? One is tempted to reply: it is our own mirror image!

Ultimately, there is nothing that is not seemingly banal in these frontal physical images of the 1980s, in which the participants, who are sometimes elegantly active, sometimes passive, enjoy highly delicate – if not perverse – situations, with a touch of humour and a few accessories.

Why is it, then, that even a simple glance at these photographs produces such an impression of unease? Surely much of it is to do with his lack of complacency. One recalls his mortified portraits of living personalities, without the slightest resemblance to those characterless models who are malleable and willing to do their master's bidding. Or the desperate solitude of his large, anthropometric nudes, among which *Violetta with Monocle*, with her undaunted nudity, articulates in a serious manner an infinite desire for silence. No. I believe that what frightens us, irritates us, or distresses us in Helmut Newton's photos is his own obsessional and obsessive presence in them.

In fact, Helmut Newton is once again demonstrating, as if there was any need, the fact that while texts may conceal images, images possess texts. And texts, for him, even more precisely than images, denote a part of ourselves that lies in the shadow of the

light, often on the verge of disgust, but which nevertheless fills our lives with emotions and sensations that one would always wish to be more intense.

Supremely indifferent – apparently almost insensitive – Helmut Newton seems to have been spared from the influence of commonplaces and repetitons. Authoritatively, and without any alibi, he presents images of a society that would be worthy of governing our conduct, beyond the taboos and social rules that entangle it.

The forcefulness of his photos lies in the implacable rigorousness of their self-confidence. Without either hypocrisy or pathos, free from all danger of seduction, they speak within themselves, of themselves. It is an inaccessible place in which, immobile, all his critical sense unfolds, his taste for play and parody, pointing the finger at us and denouncing our weaknesses. With Helmut Newton, an aesthetic force is asserted by a narrative consciousness that is the very nerve centre of that force itself; in others, this force only becomes effective through anecdote, or through the situation it reveals.

At the request of Jean-Luc Monterosso, Helmut Newton has assembled here a large number of unpublished photos, some of which relate to architecture, interspersed with 'straight nudes with no overt sexual connotations'. Mischievously, he promises to behave himself. Nothing could be easier or more stimulating. So he gets down to work, selecting from 11,000 contact prints the photos that make up this exhibition, excluding provocative nudes, Hollywood stars, and faces that are too well known. Once his selection is made, he submits it to June so that, in her hands, the 'archives of night' will see the light of day.

Because, subconsciously, Newton's art communicates through its desire to tell its story. Juxtapositions become charged here with an exceptional evocative power. Replying to themselves with visual echoes, his photos reinforce their own narrative richness, produ-cing perfect alliances between satire and poetry, brutality and gentleness, irony and sen-timentality ... They set the most complex signs of an ideal syntax side by side, con-densed together.

Let us look at the photographs he is showing us. The *Domestic nudes* give expression to the perfect woman, who according to him is able to flourish in harmony with her own contradictions. Or, to put it differently, she overcomes her fears, does not flinch from danger, surrenders herself for pleasure, is wary of causing annoyance ... but above all, she is herself, she rejects every idea of imitation. The setting – kitchens cluttered up with domestic appliances – forestalls any nihilistic impulse. The *Bersaglieri Holding Ferragamo Shoes* alongside the *Butcher's Shop Window* reveals his taste for irony and revolting contrasts. From a group of lively young people he creates an unwholesome novel, and he celebrates the beauty of a calf's head decorated with parsley. My favourite diptych, without any doubt, is *June Resting* (taken when Helmut Newton was in hospital in New York following a heart attack) alongside *The Sea at the Heliport*. The mask, like

the padding of the bed, paradoxically suggests that the loss of silence is perhaps humanity's greatest misfortune. A motionless misfortune, in the isolation of a hotel room into which her effort to outdo herself in providing him with new hope, that evening, had cast her. To sleep, to reach the horizon in order to set off afresh. And nevertheless, in the photo, her mask masks her uneasiness poorly.

With his creative power, his provocative questions, and the clarity of his formal language, Helmut Newton is writing our own story; more precisely, it is the story of a man without illusions.

And in this, his work can lay claim to universality.

José Alvarez

ARCHIVES DE NUIT

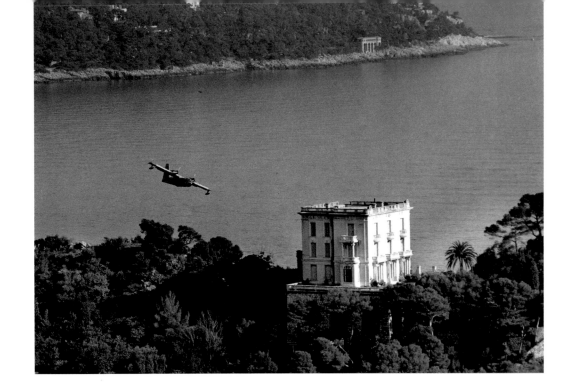

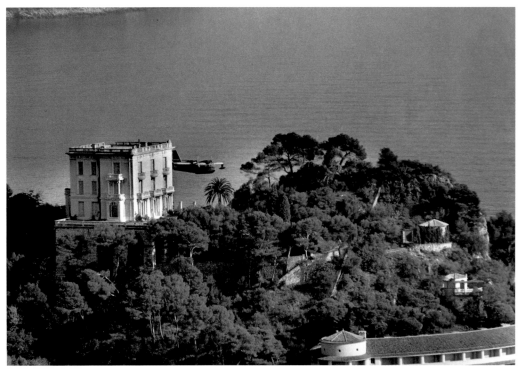

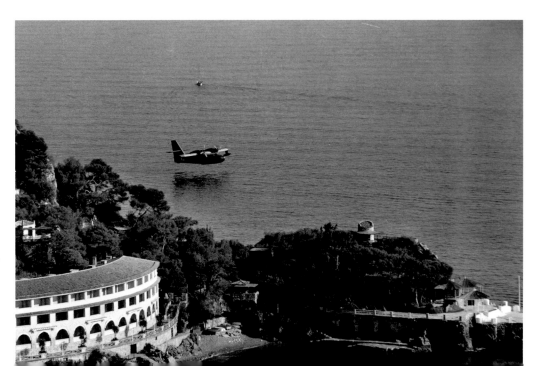

**1 Canadair over »La Vigie« and
Monte-Carlo Beach Hotel, 1985** ▶

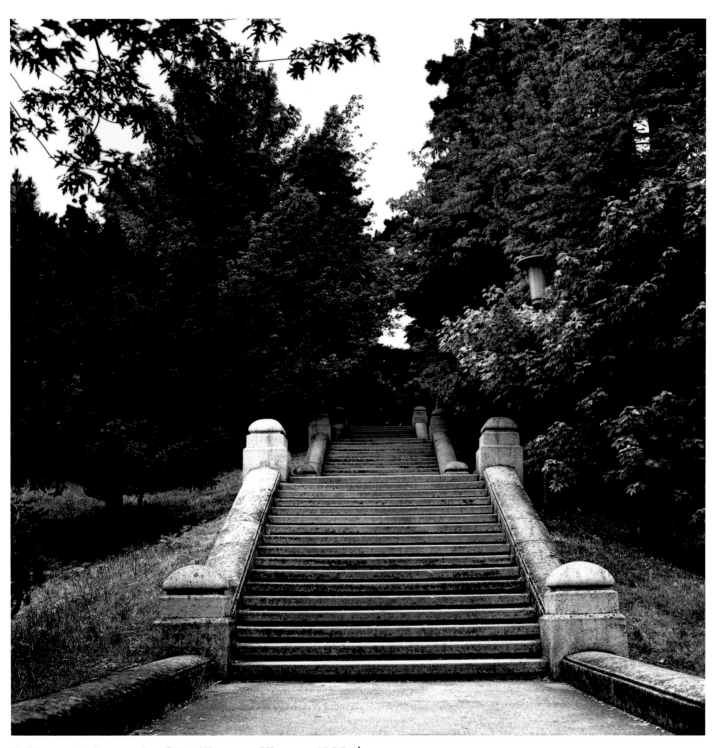

2 Stone staircase by Otto Wagner, Vienna 1992 ▲

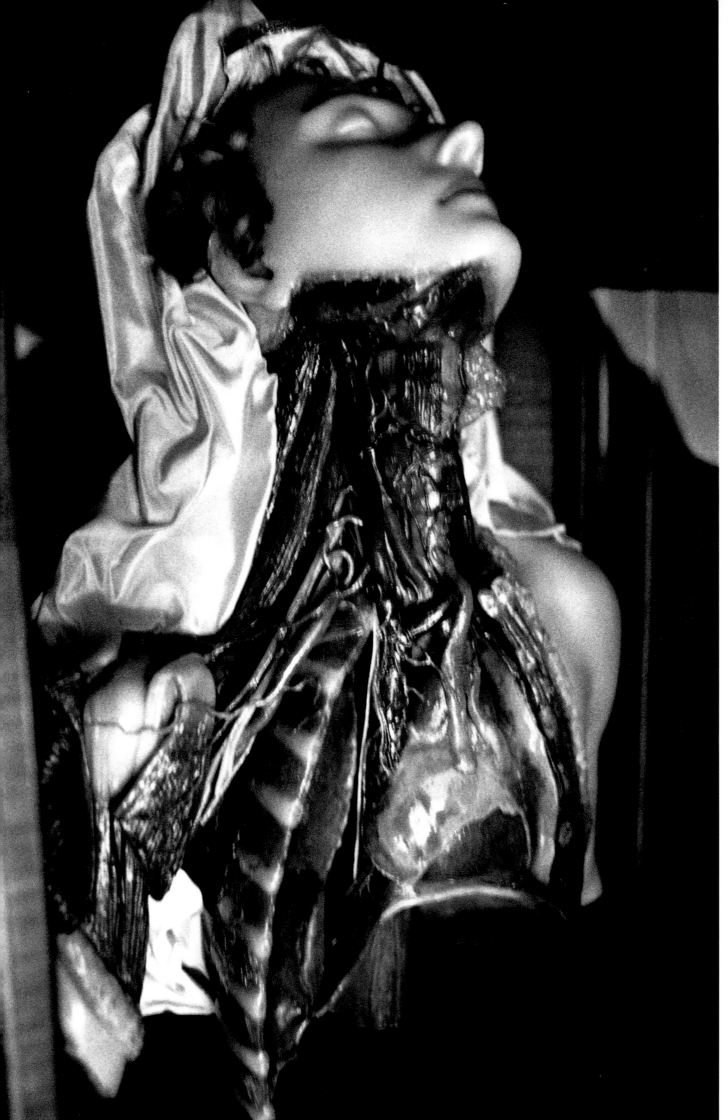

3 In Prof. Holubar's Josefinum I, Vienna 1992 ▲

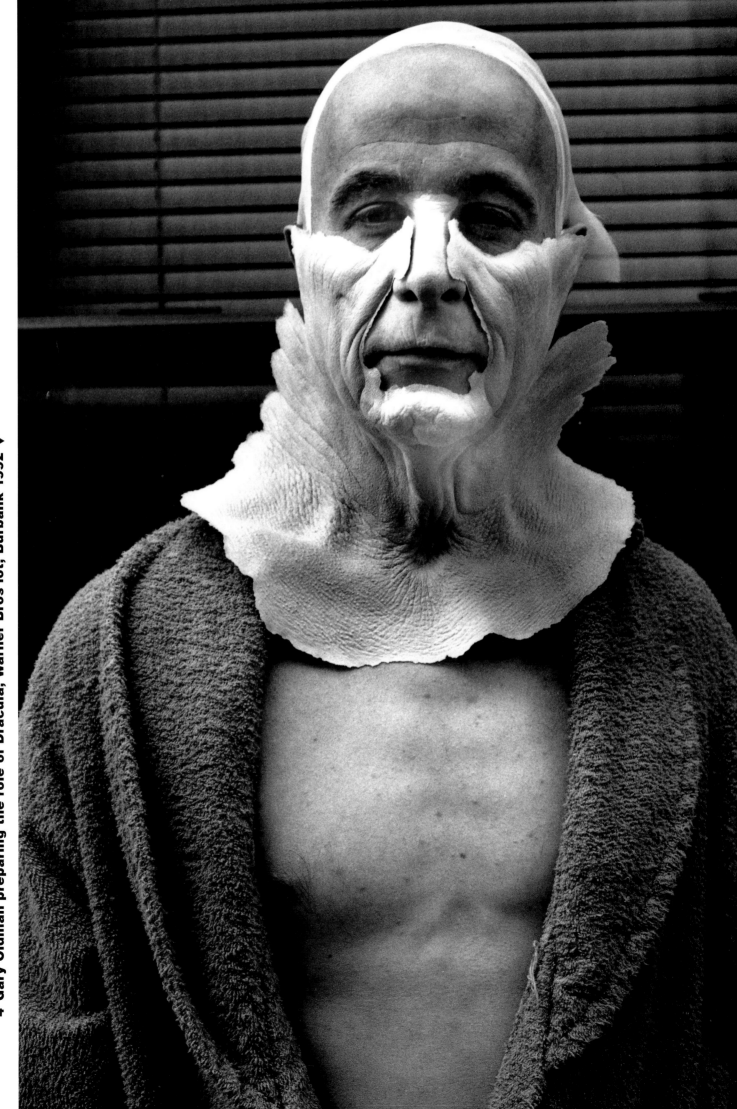

4 Gary Oldman preparing the role of Dracula, Warner Bros lot, Burbank 1992 ▼

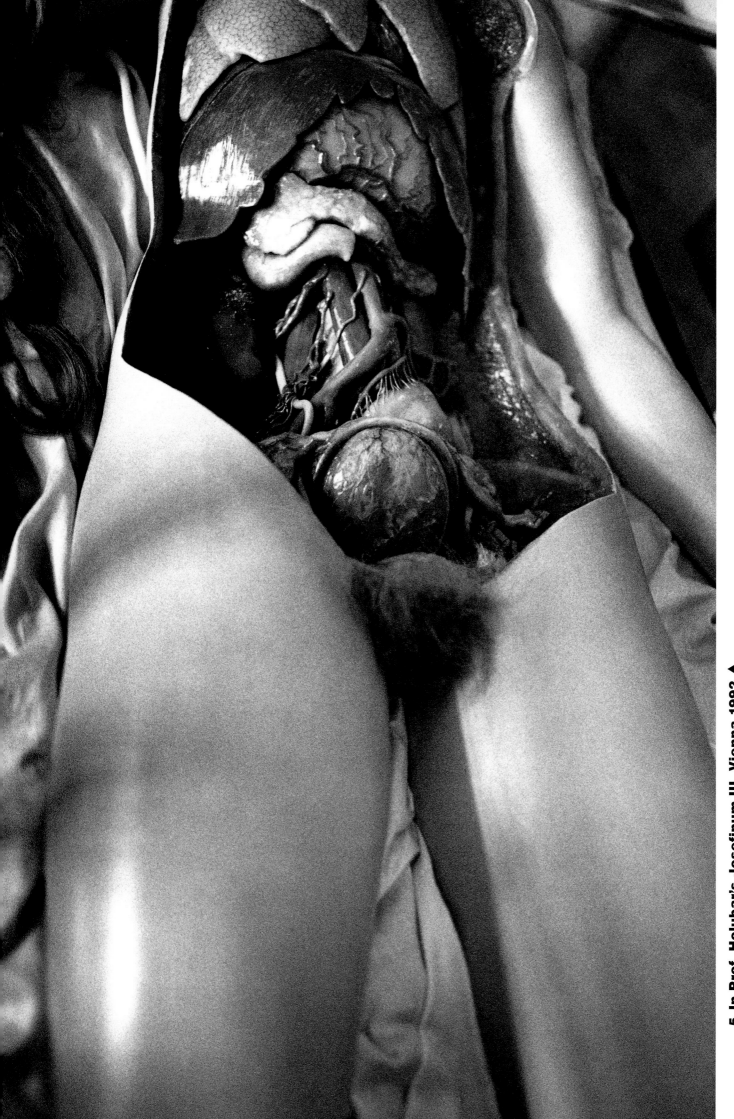

5 In Prof. Holubar's Josefinum III, Vienna 1992 ▲

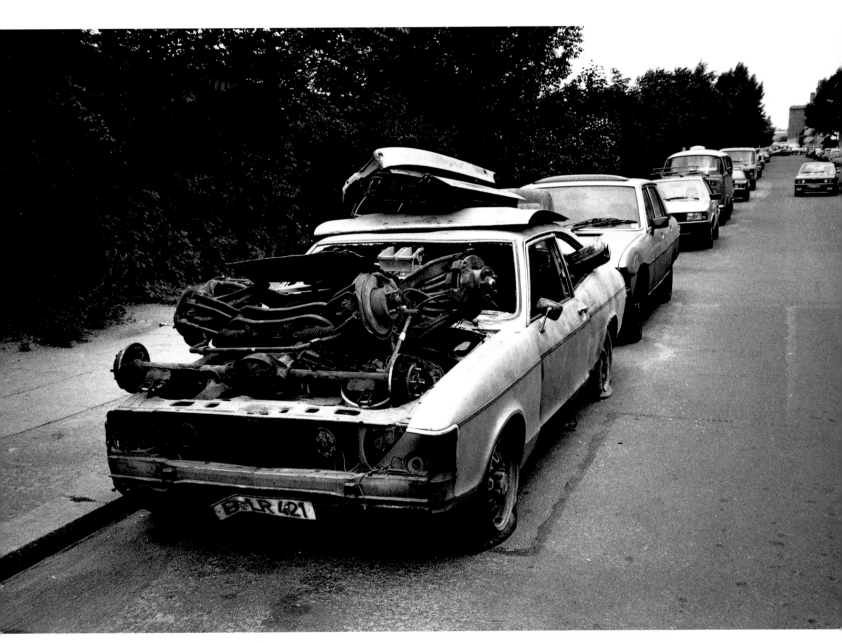

6 Parked car, Berlin 1988 ▲

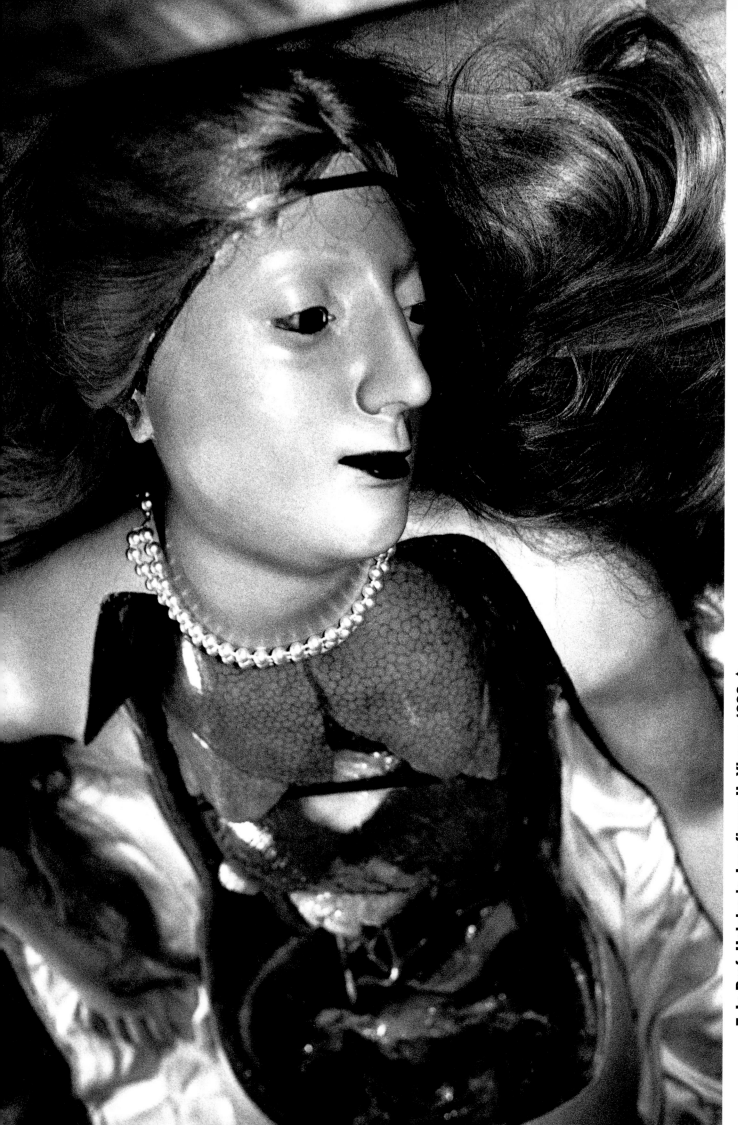

7 In Prof. Holubar's Josefinum II, Vienna 1992 ▲

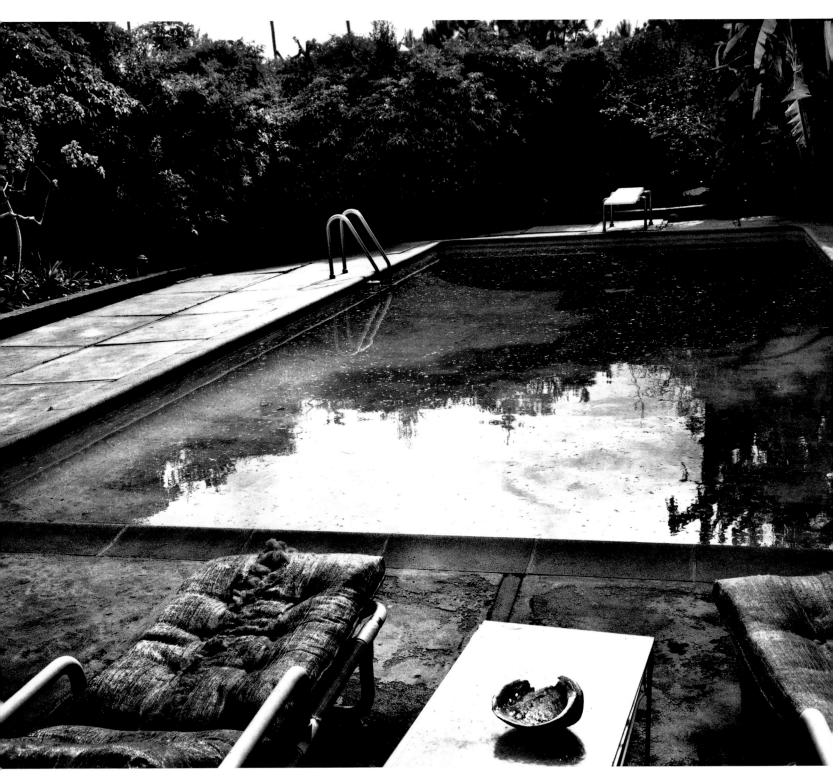

8 Swimming pool in James Mason's widow's house, Beverly Hills 1989 ▲

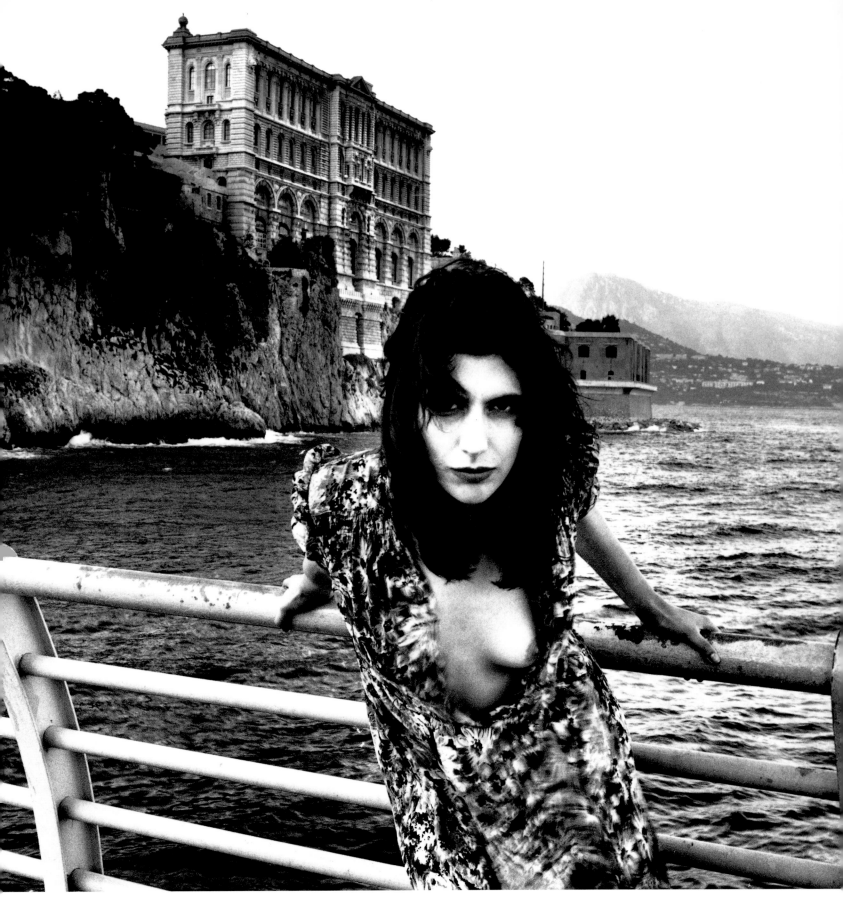

9 Young woman & Oceanographic Museum, Monaco 1988 ▲

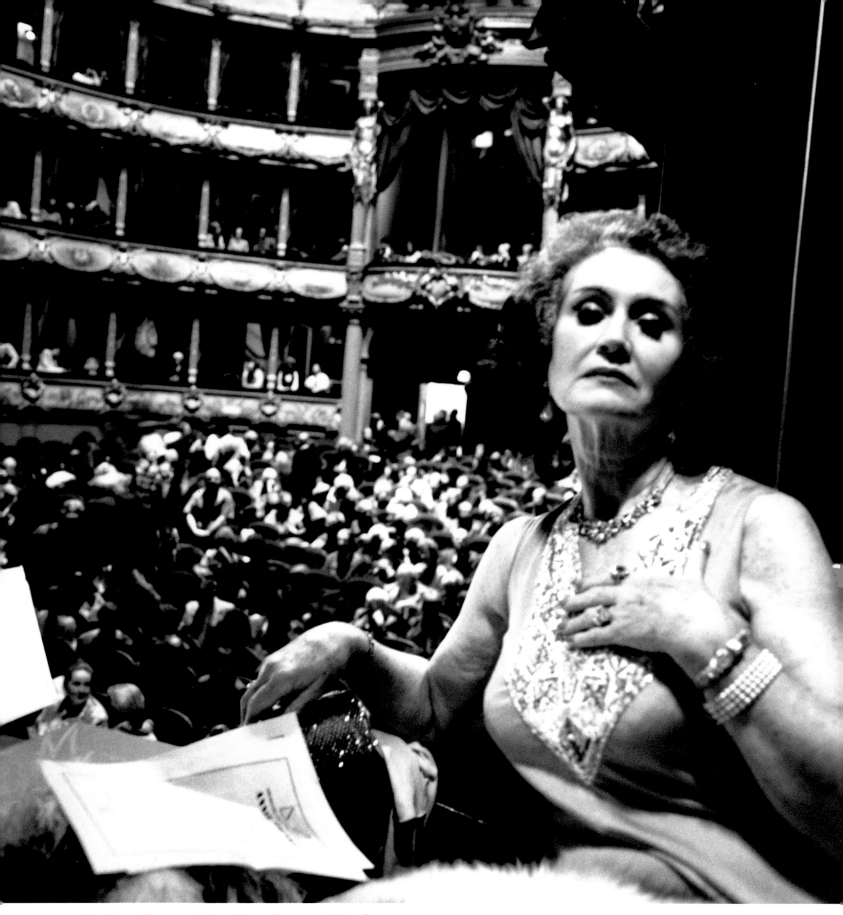

10 Frau Sauer at the Nice Opera, 1991 ▲

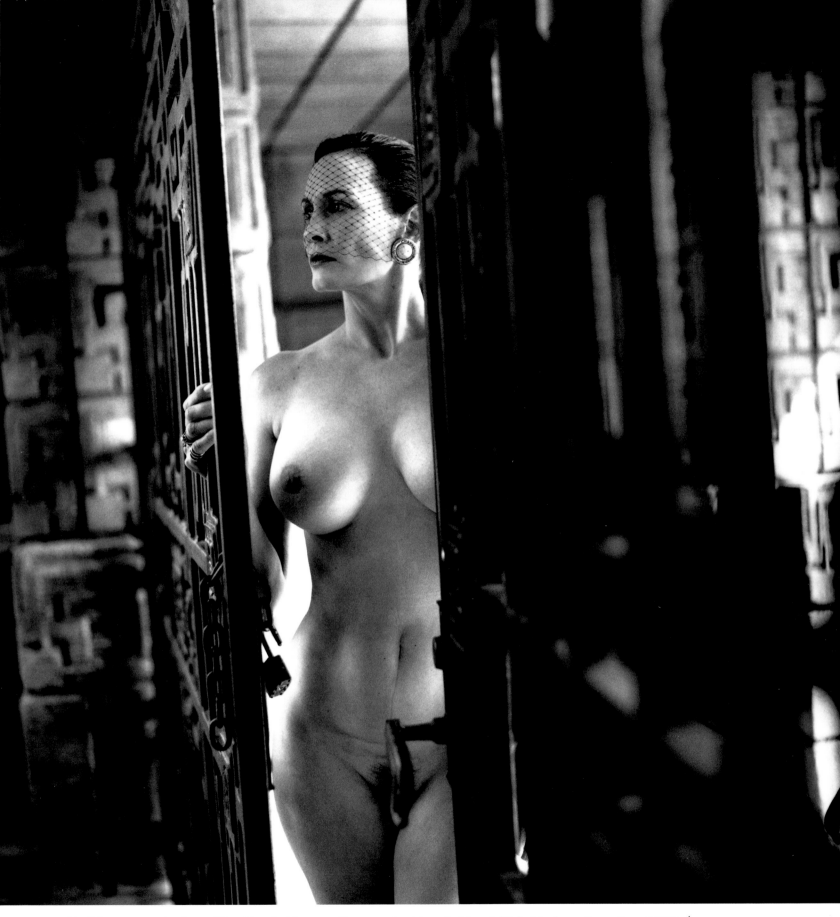

11 Woman entering »The Ennis-Brown House« by Frank Lloyd Wright, Los Angeles 1990 ▲

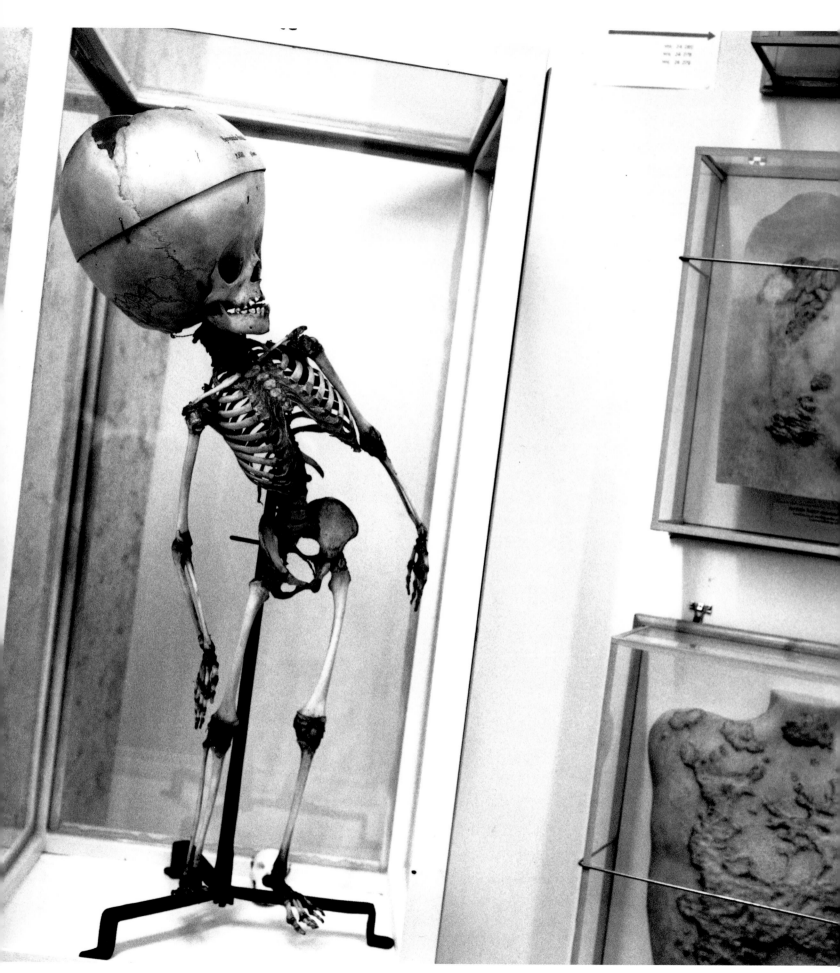

12 In the »Fools' Tower«, Vienna 1992 ▲

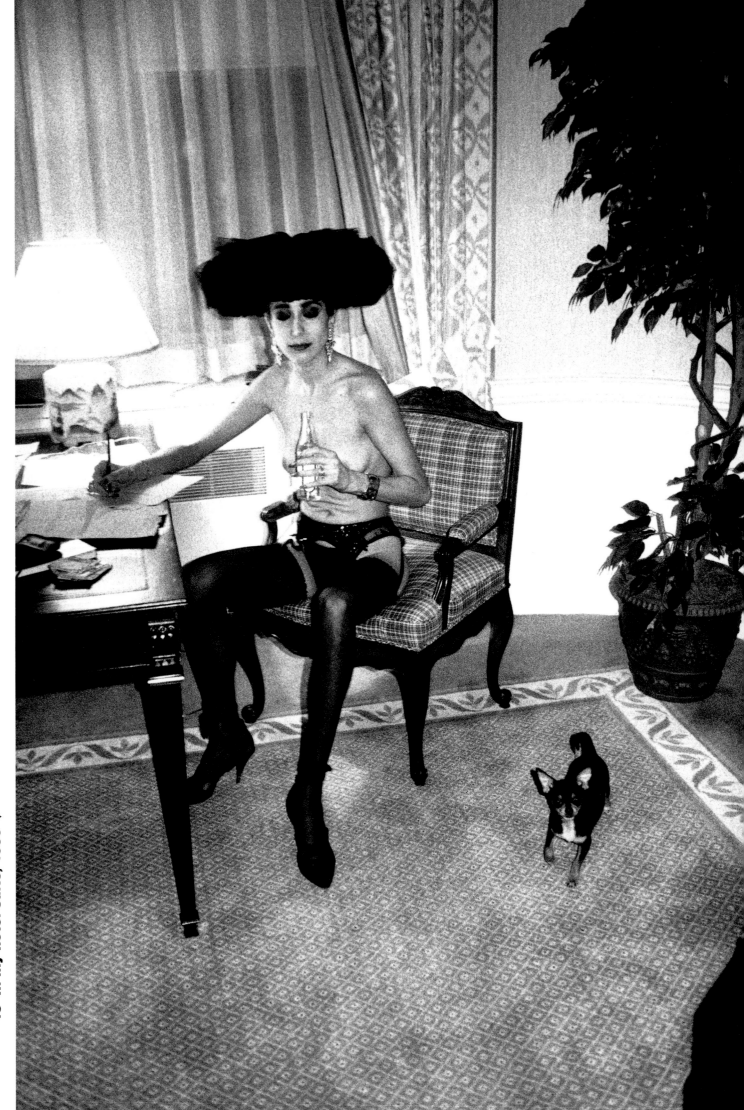

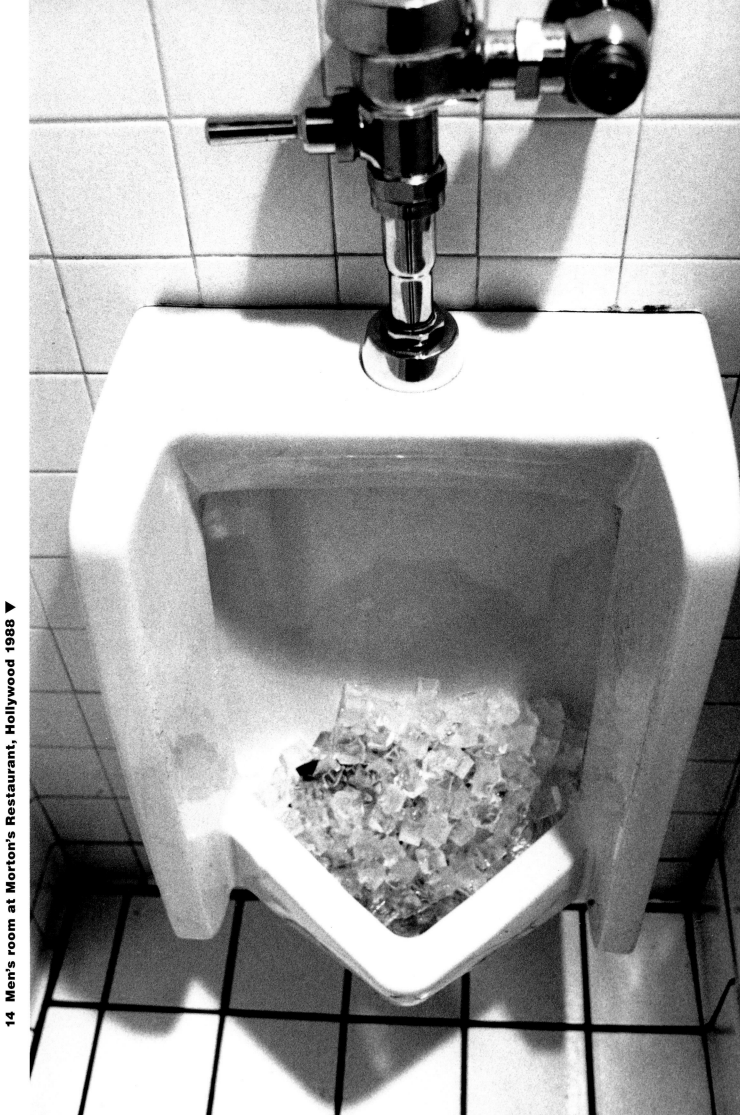

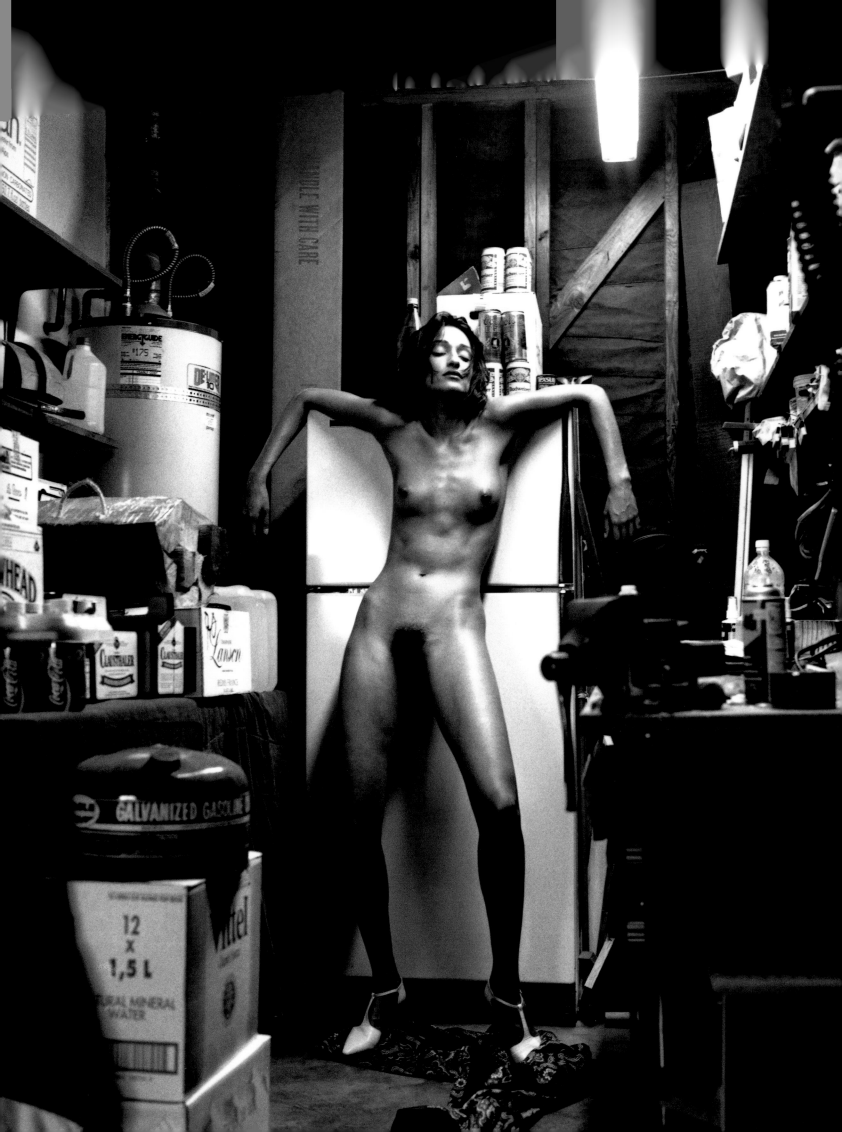

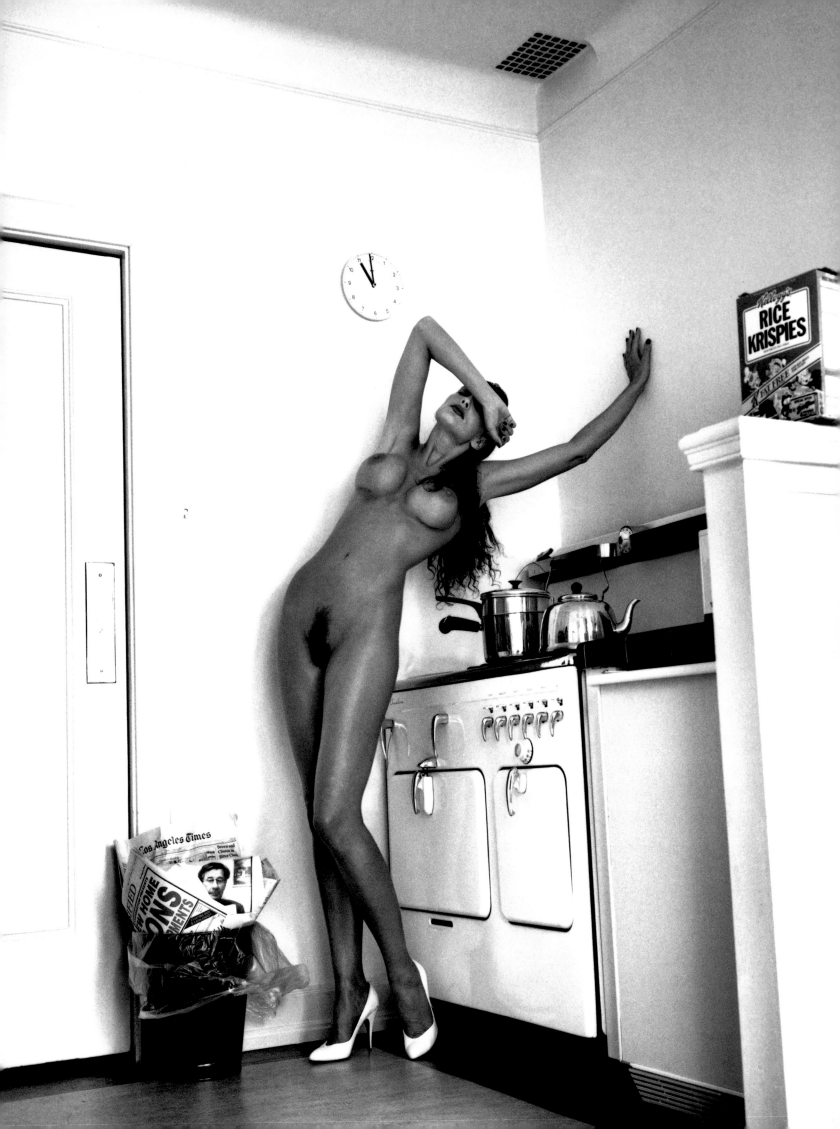

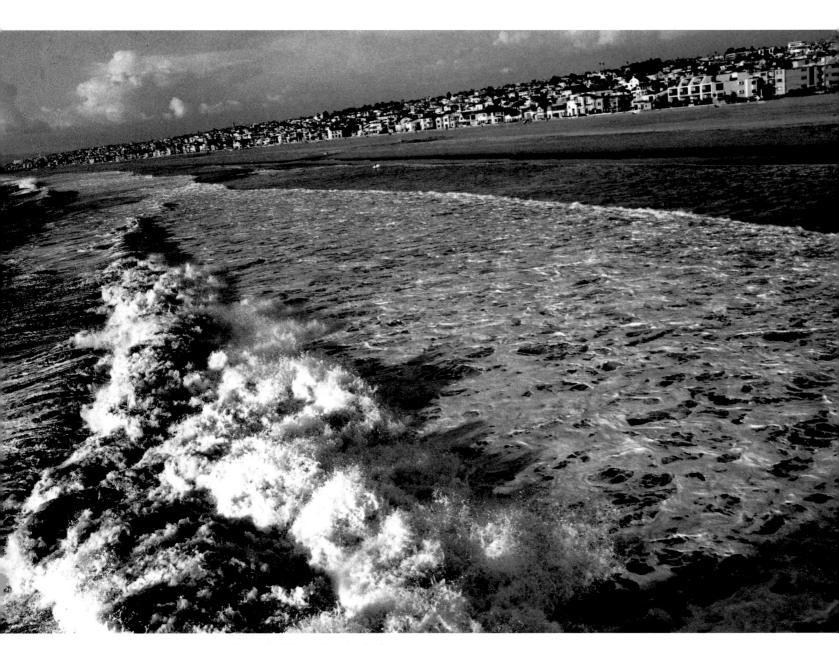

17 The Pacific at Venice, California 1990 ▲

Previous pages:

15 **Domestic nude II – Waiting for the earthquake, Los Angeles 1992** ◄◄
16 **Domestic nude I – In my kitchen, Chateau Marmont, Hollywood 1992** ◄

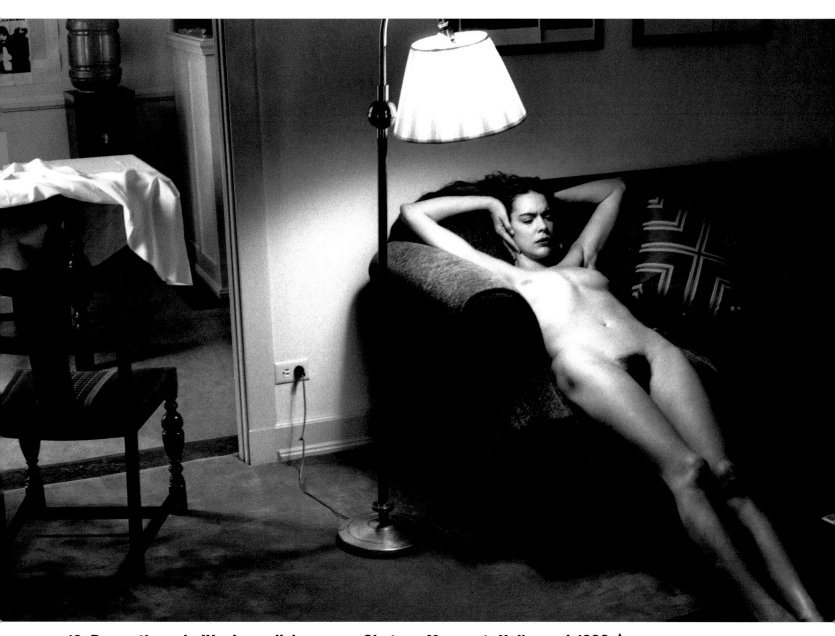

18 Domestic nude IV – In my living room, Chateau Marmont, Hollywood 1992 ▲

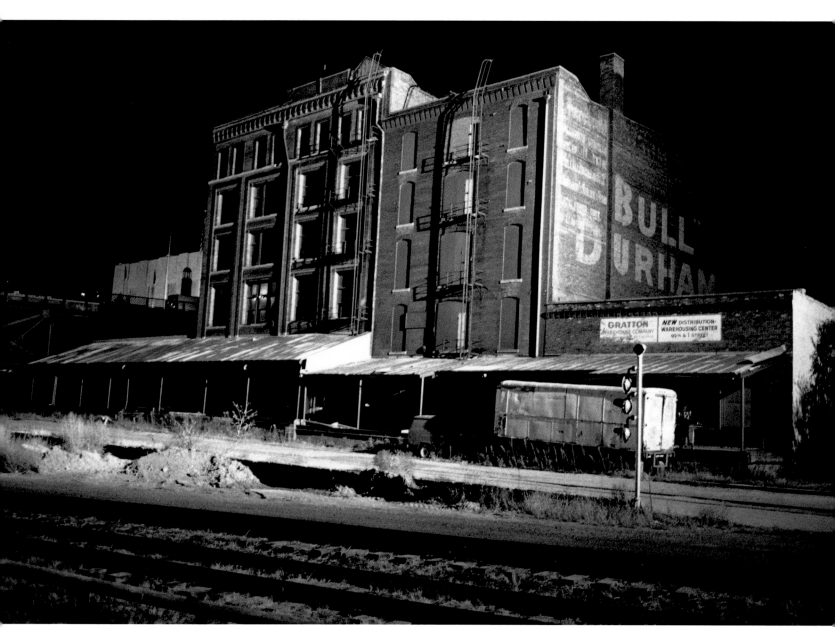

19 Railroad siding of the »Santa Fe« railroad, Omaha, Nebraska 1990 ▲

20 Domestic nude V – In my living room, Chateau Marmont, Hollywood 1992 ▶

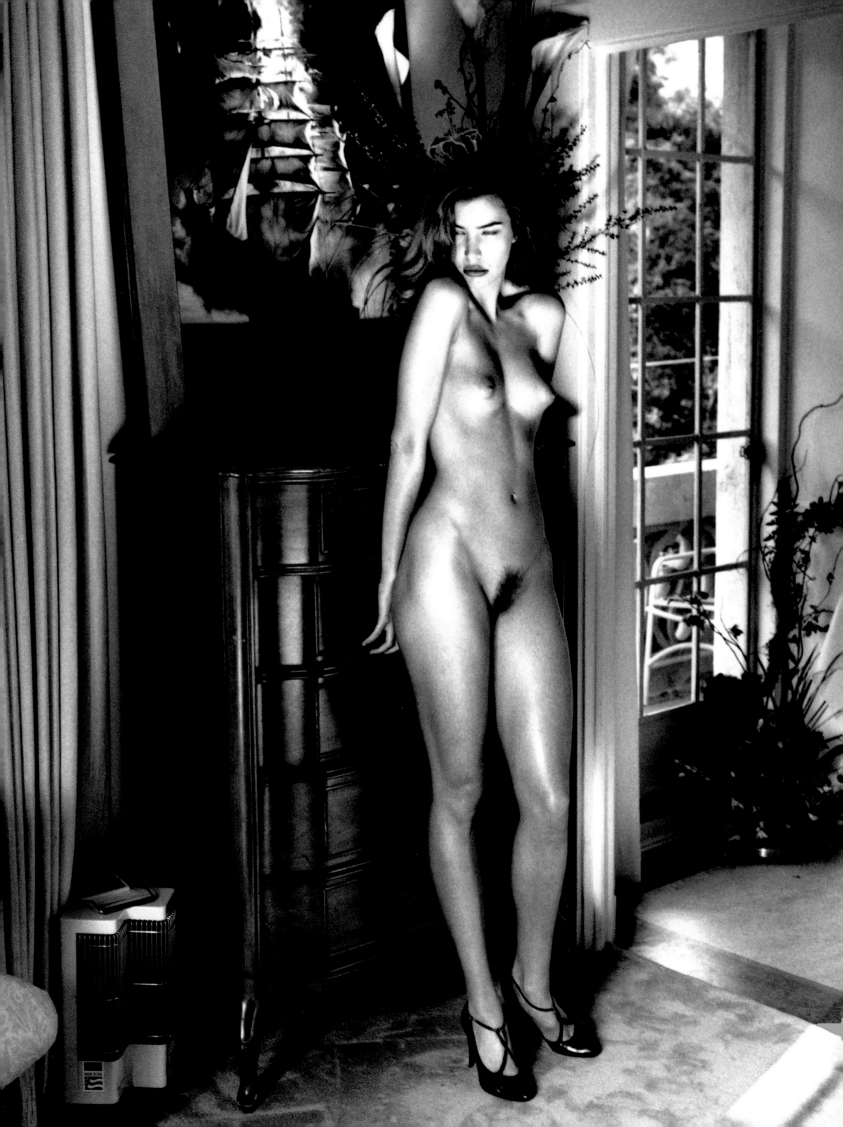

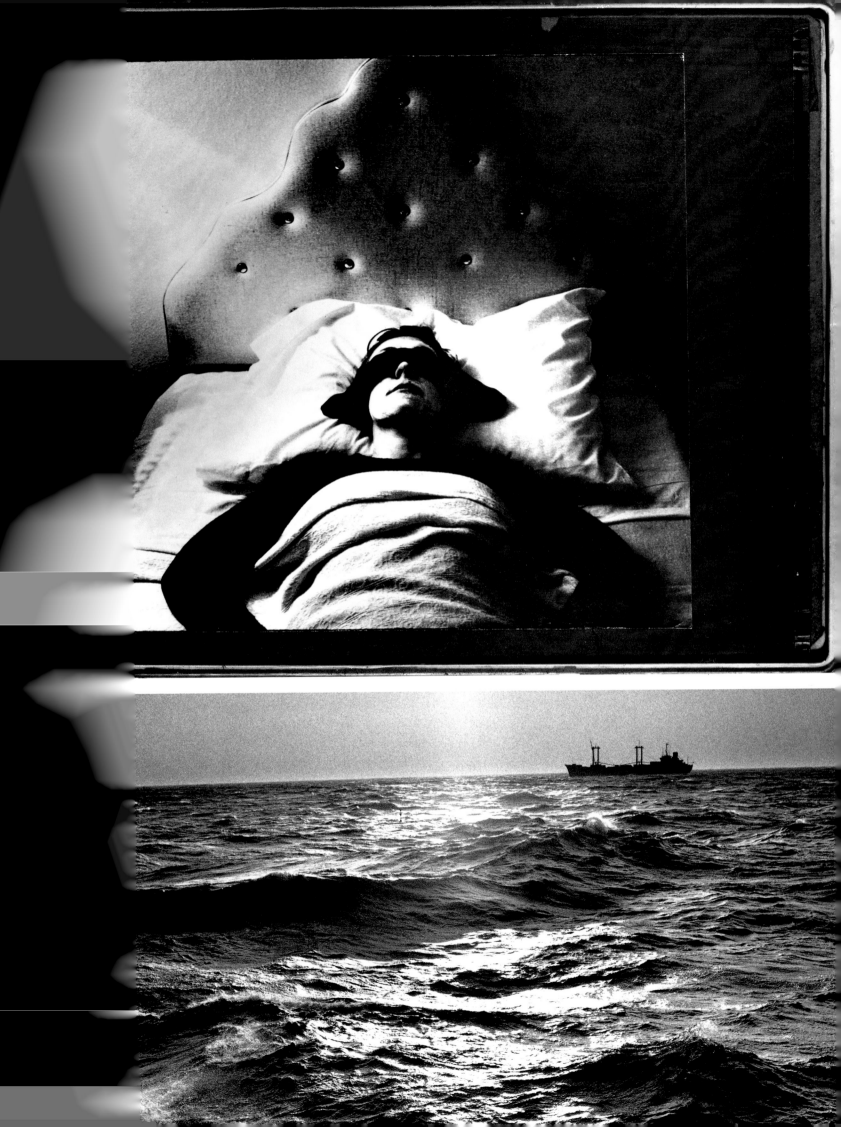

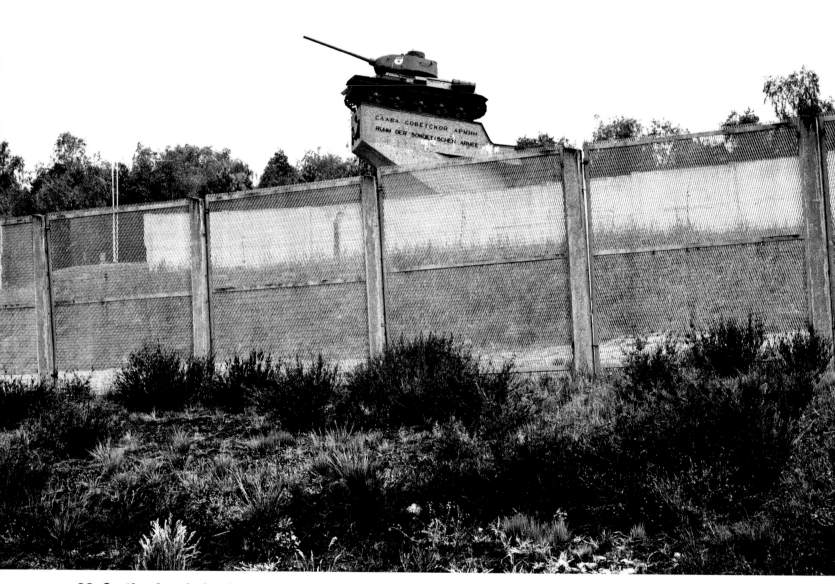

23 On the Autobahn from Berlin, going east, 1990 ▲

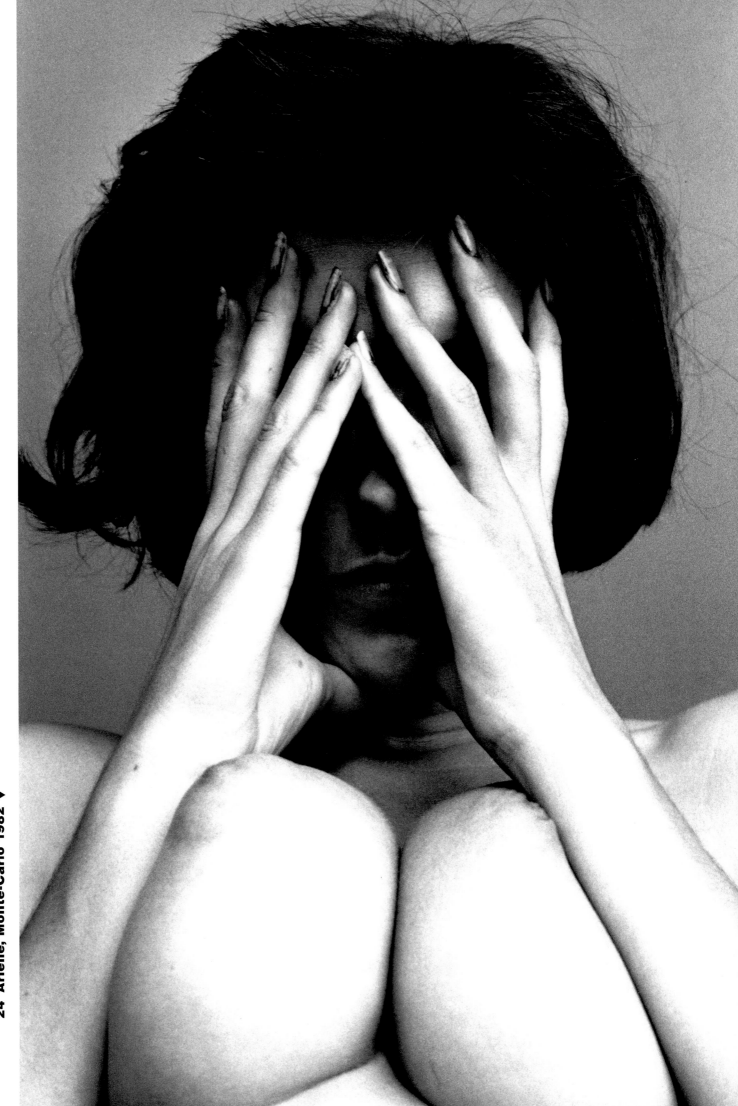

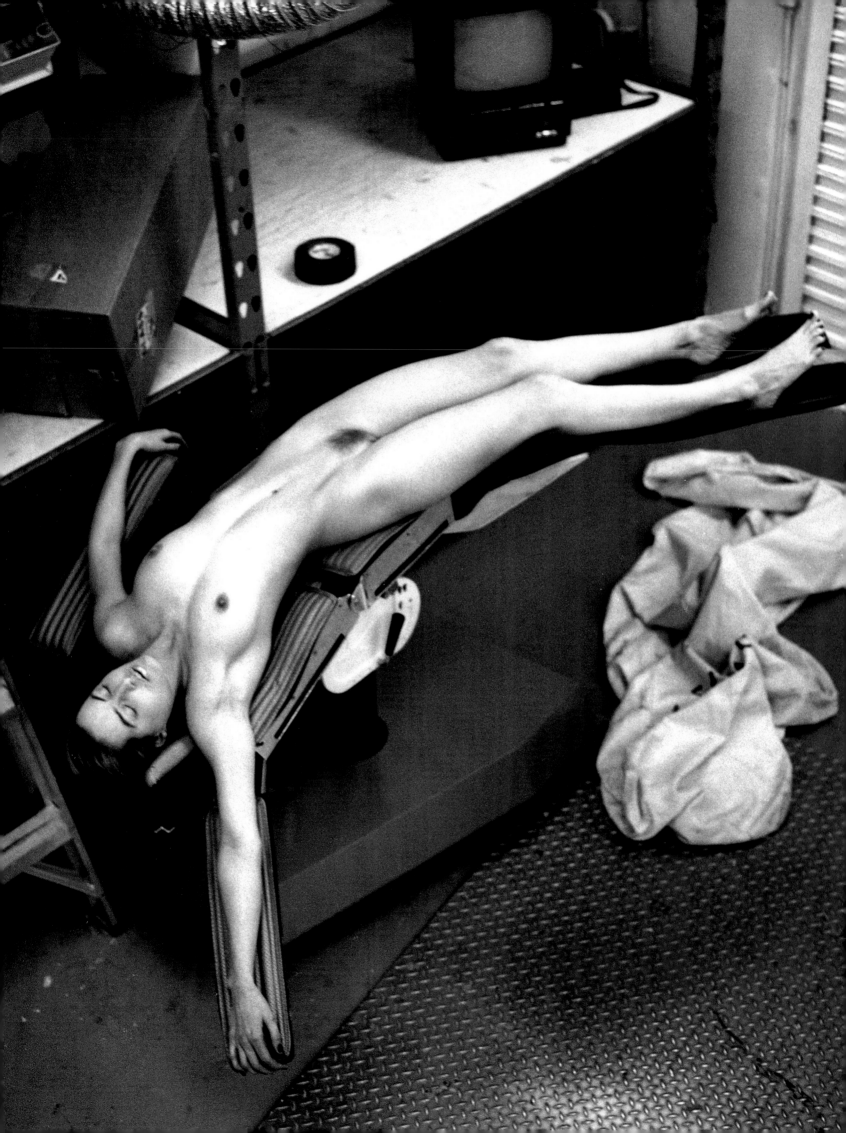

25 Reclining nude, Hollywood 1988 ▲

26 Dead mountain lion, California 1992 ▼

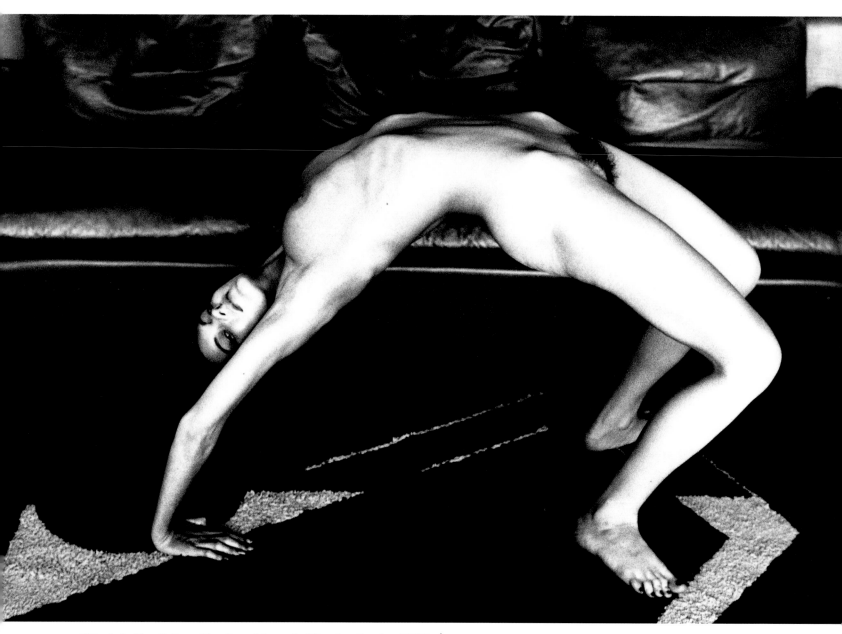

27 Arielle doing the backbend, Monte-Carlo 1982 ▲

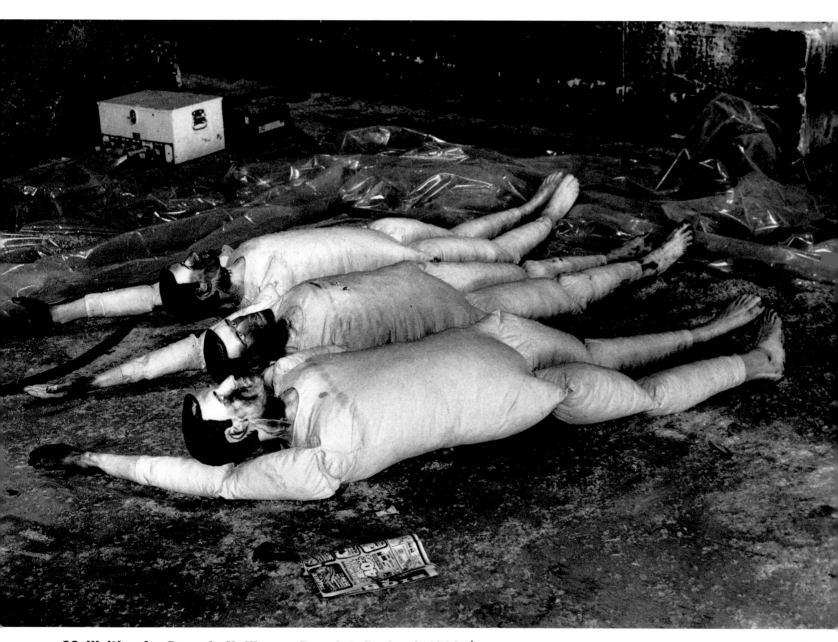

28 Waiting for Dracula II, Warner Bros lot, Burbank 1992 ▲

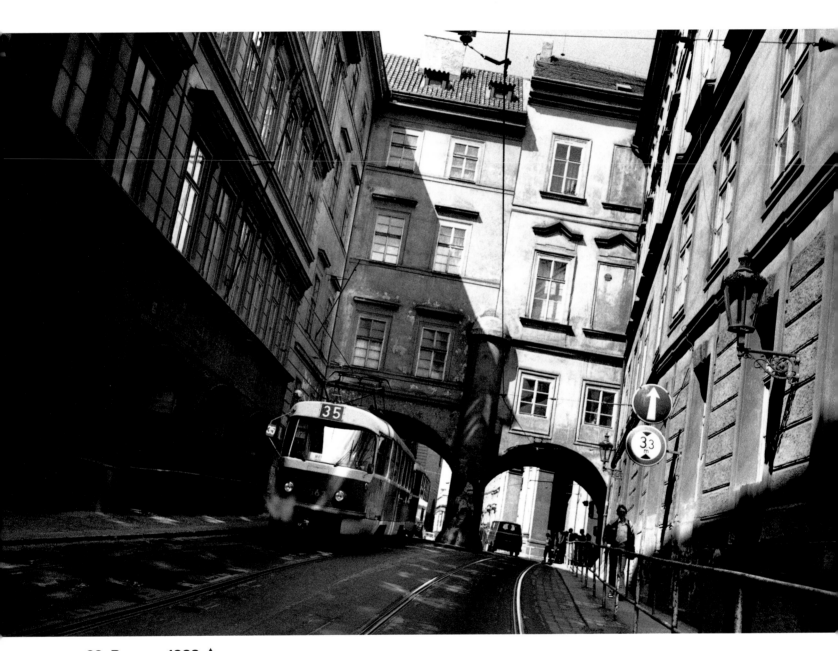

29 Prague 1988 ▲

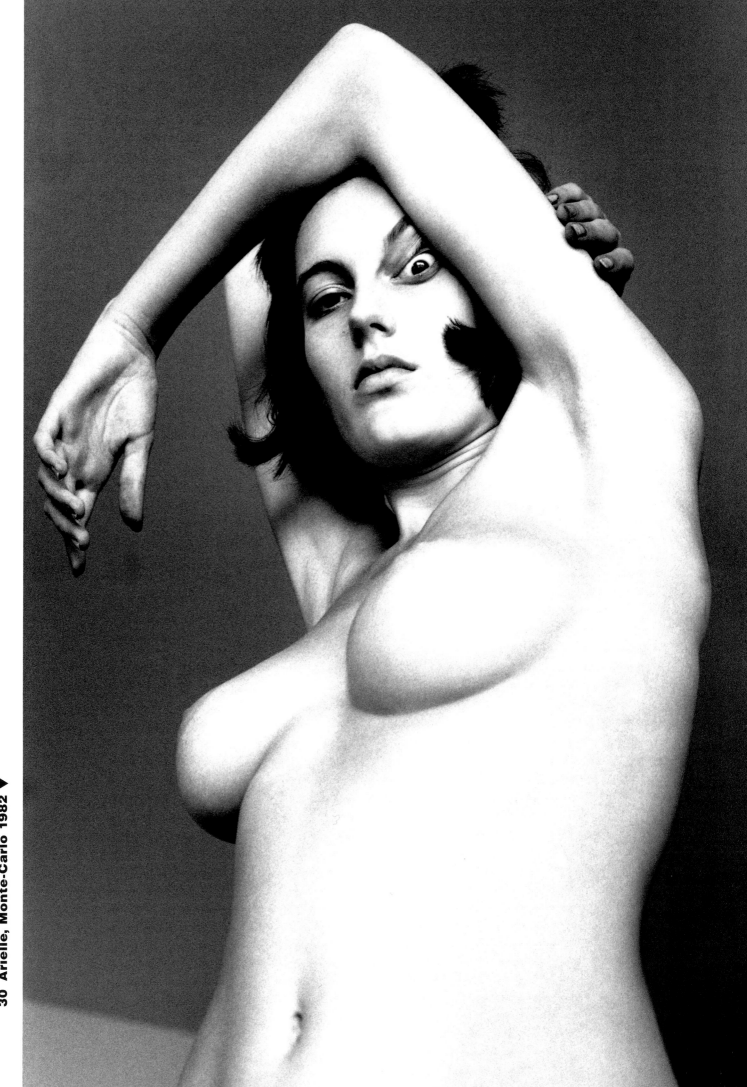

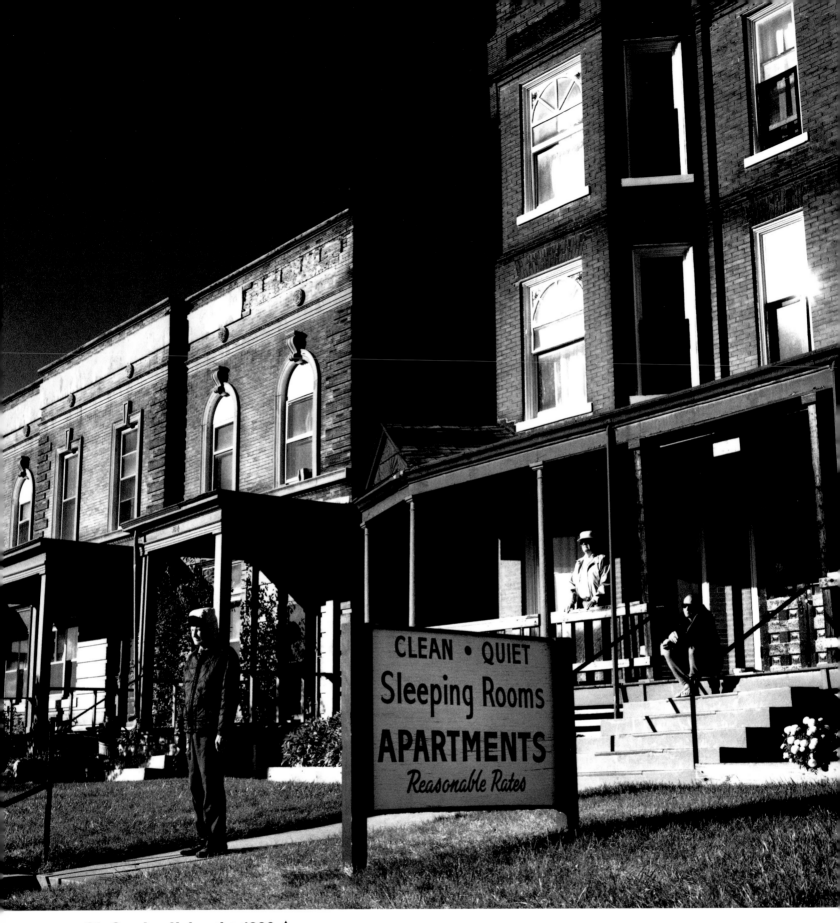

31 Omaha, Nebraska 1990 ▲

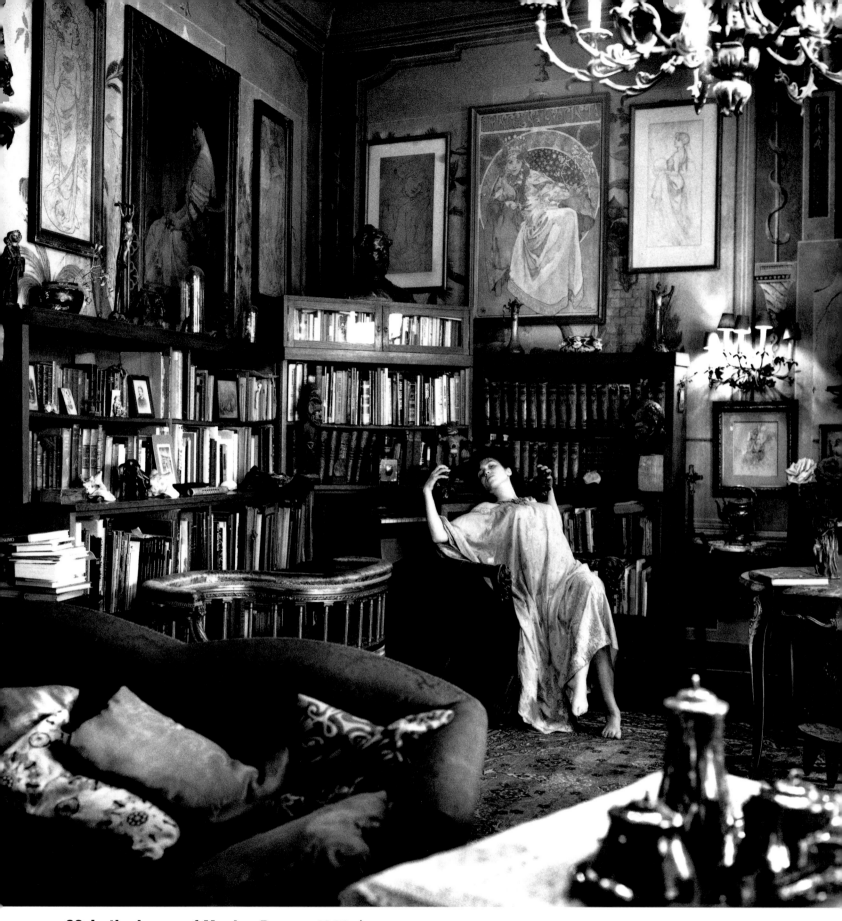

32 In the house of Mucha, Prague 1988 ▲

33 Domestic nude III – In the laundry room, Chateau Marmont, Hollywood 1992 ▶

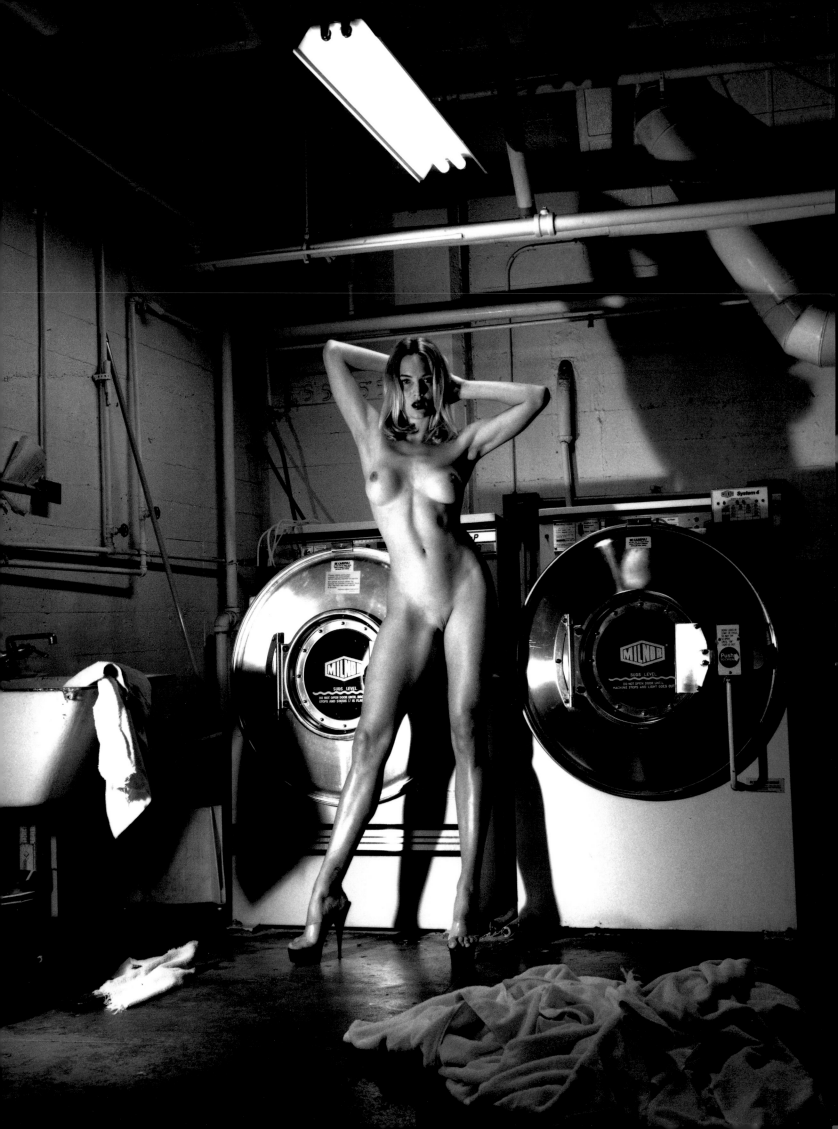

34 Domestic nude VI & art dealer, Pacific Palisades, California 1992 ▶

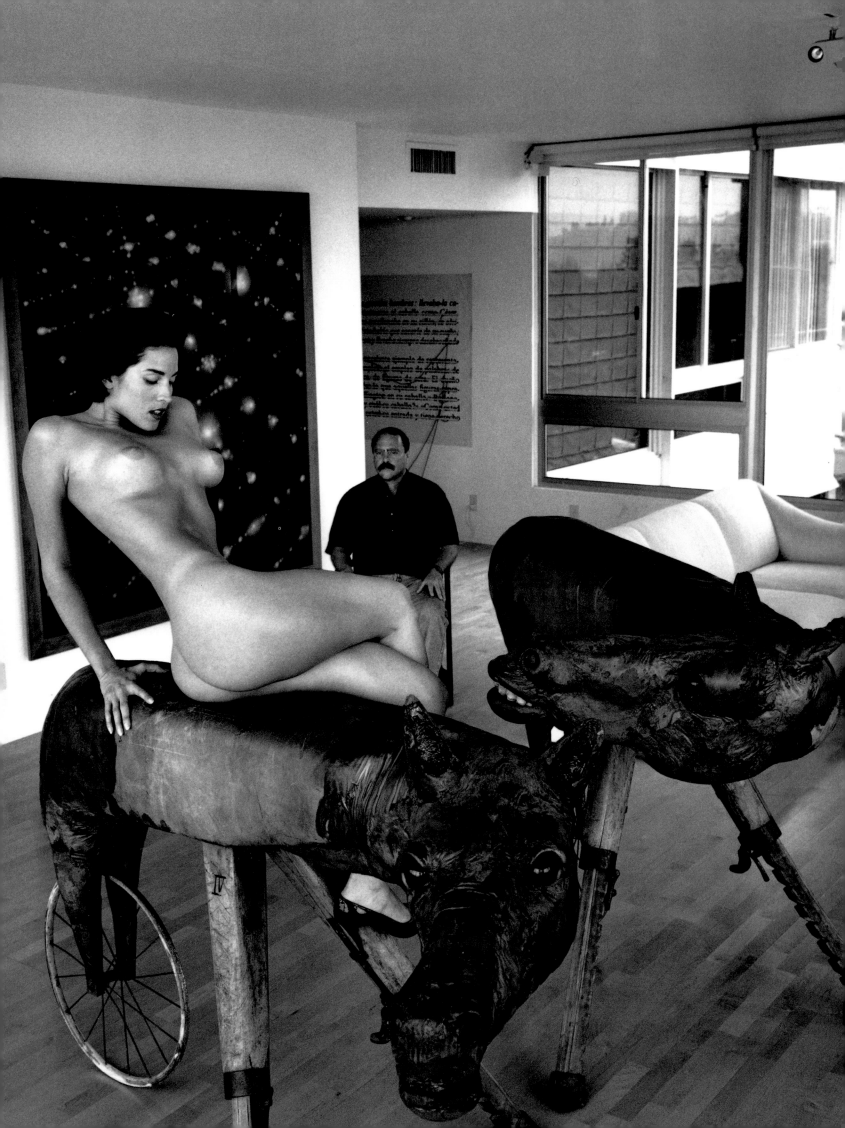

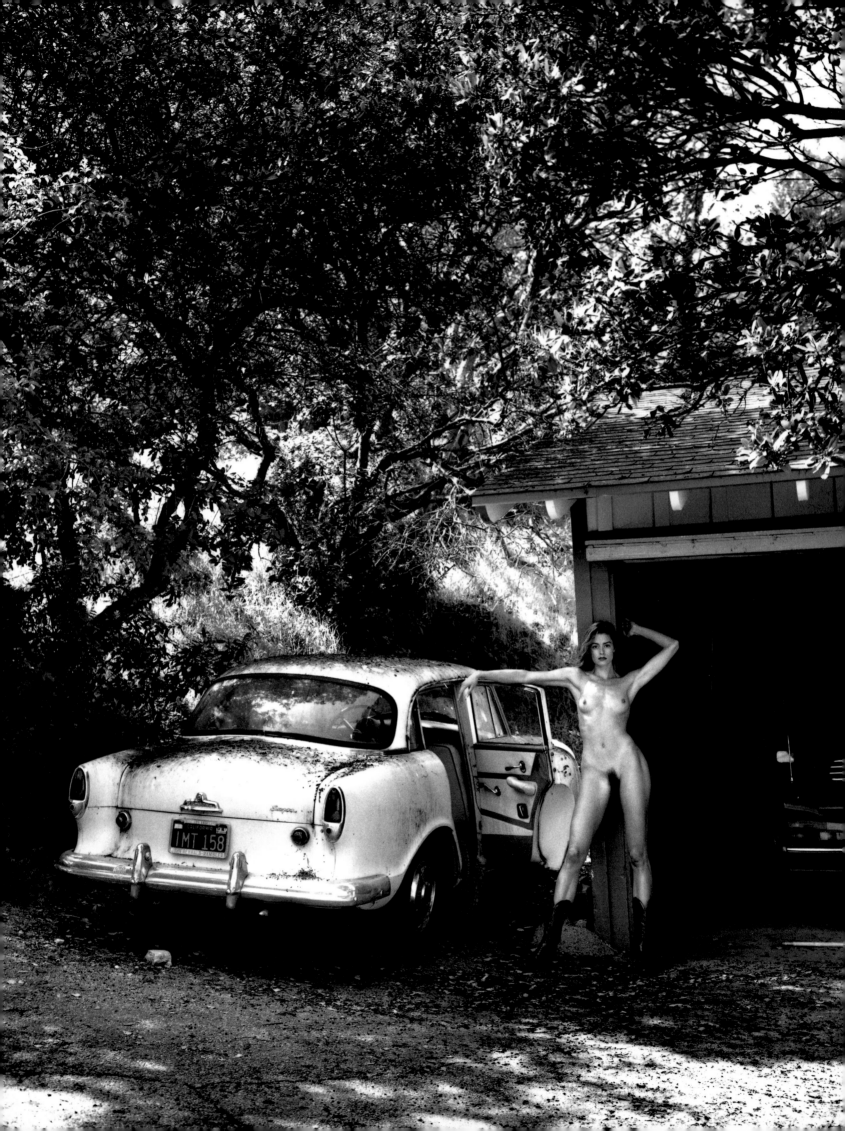

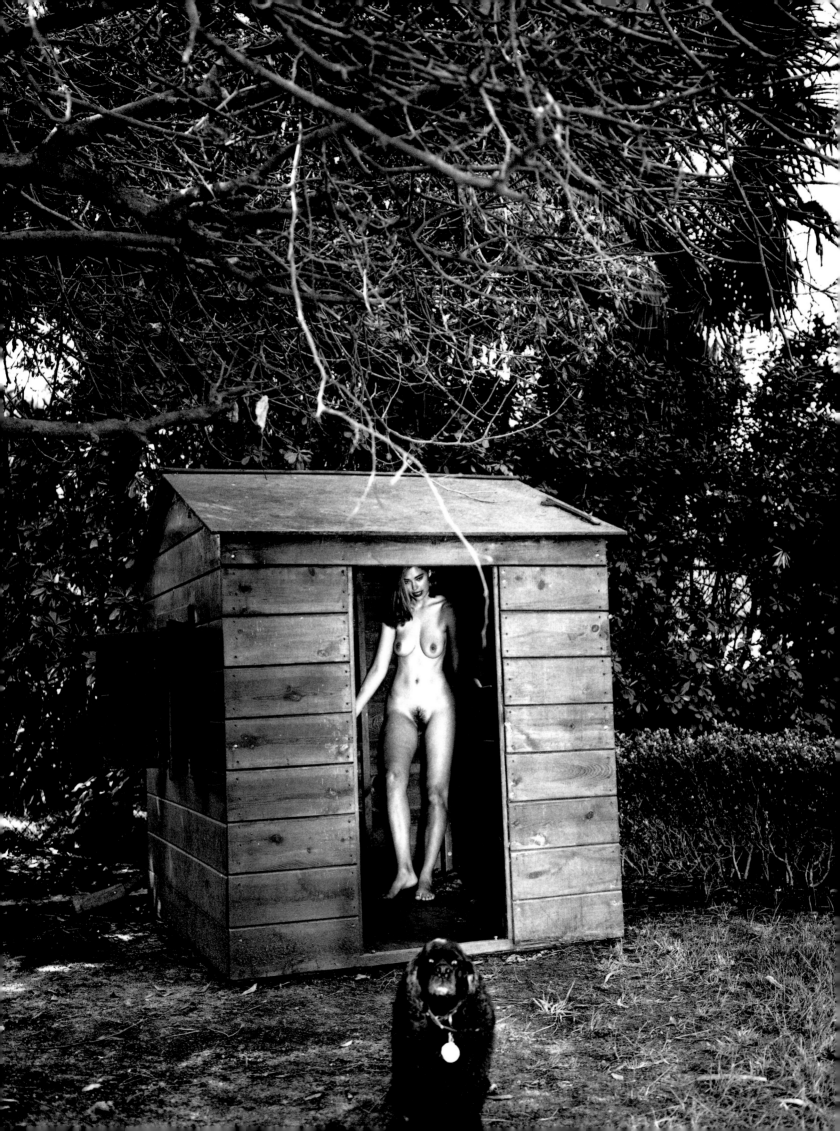

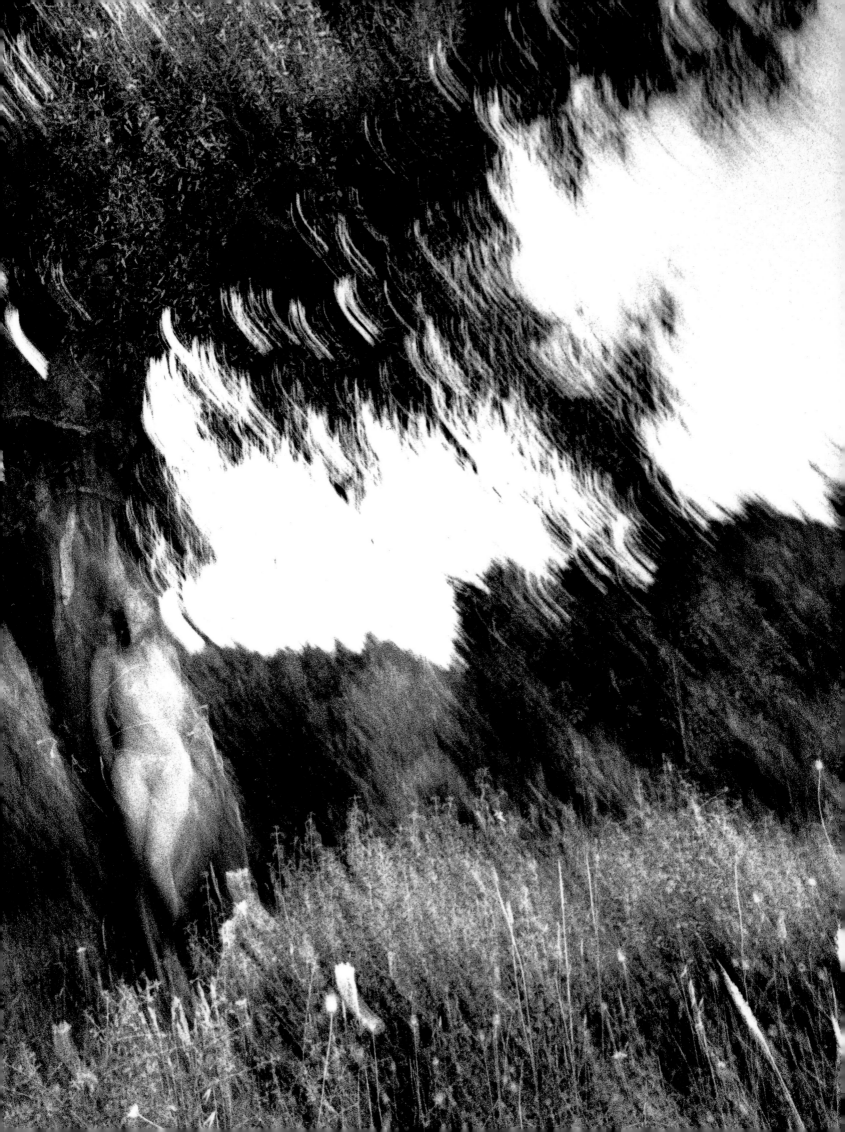

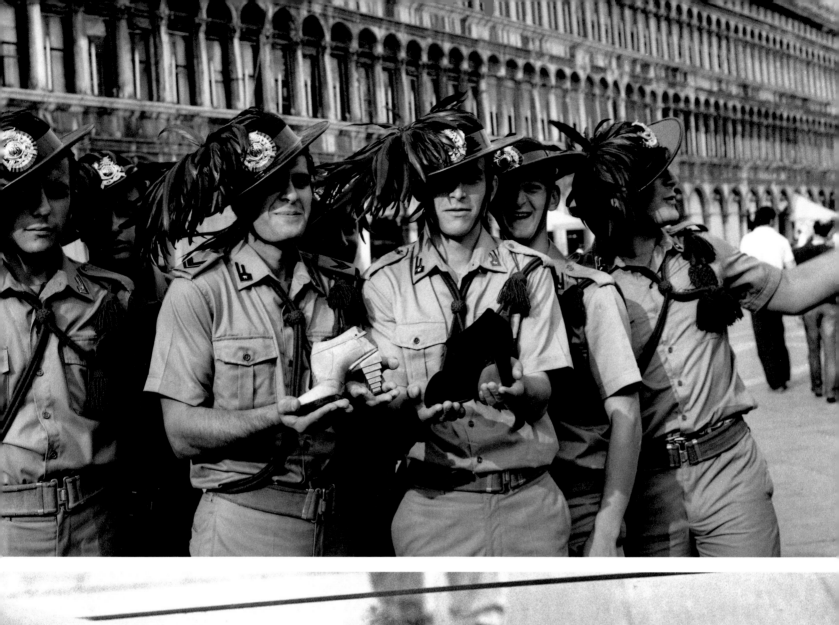
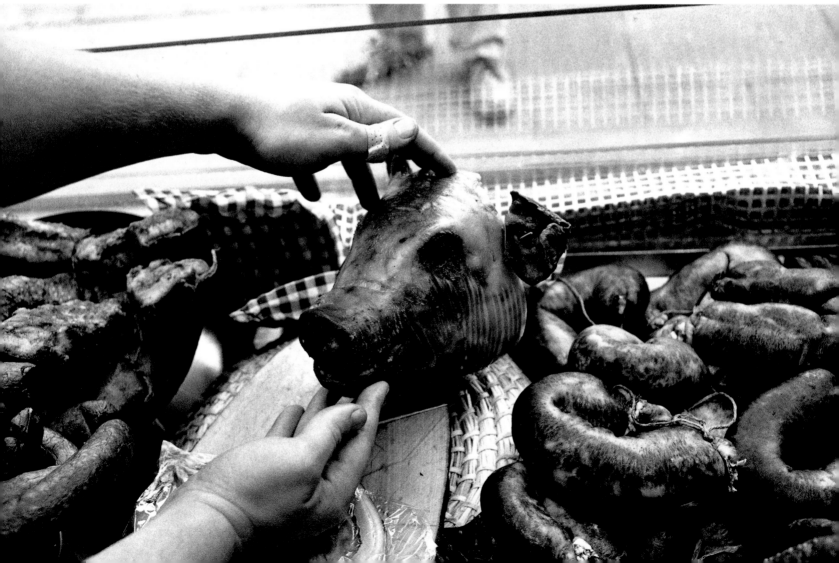

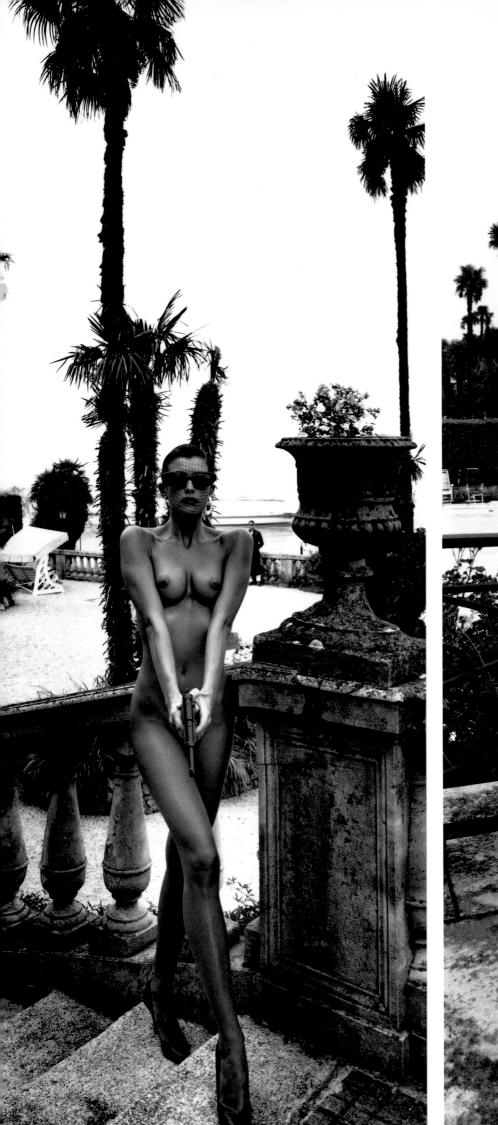
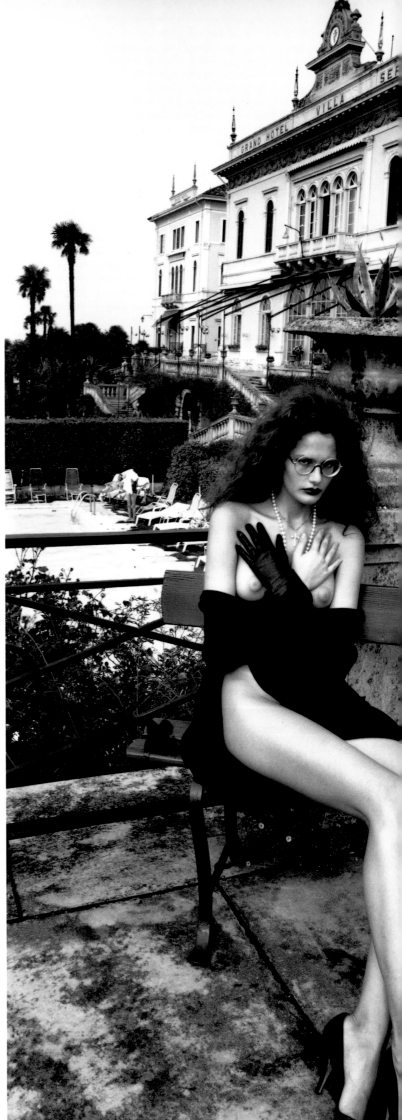

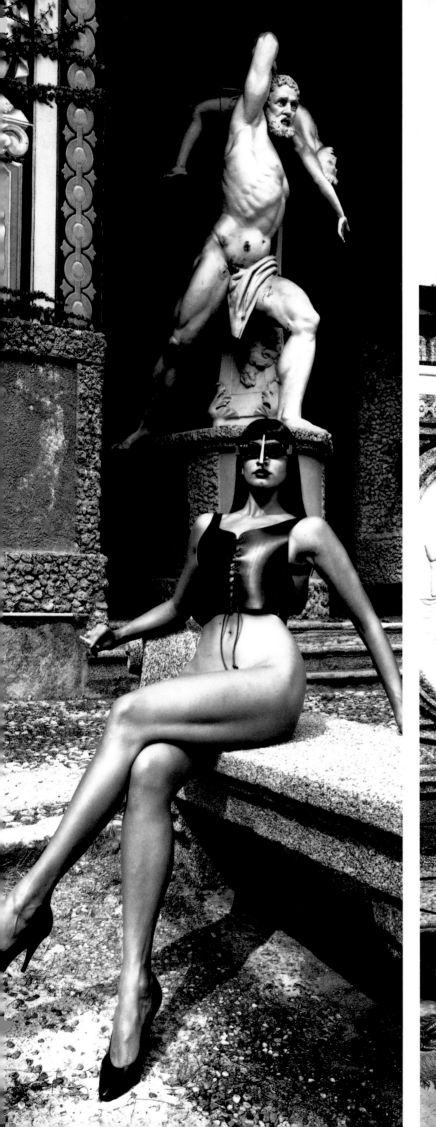
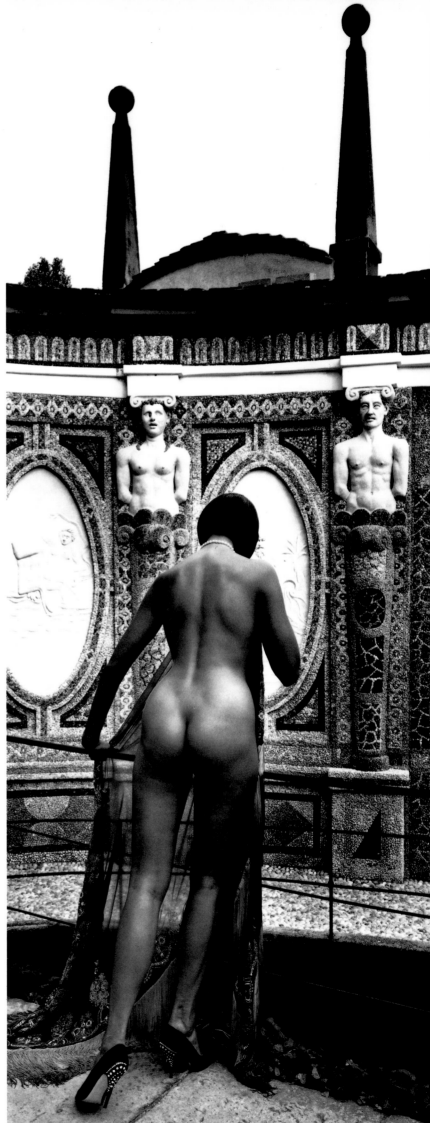

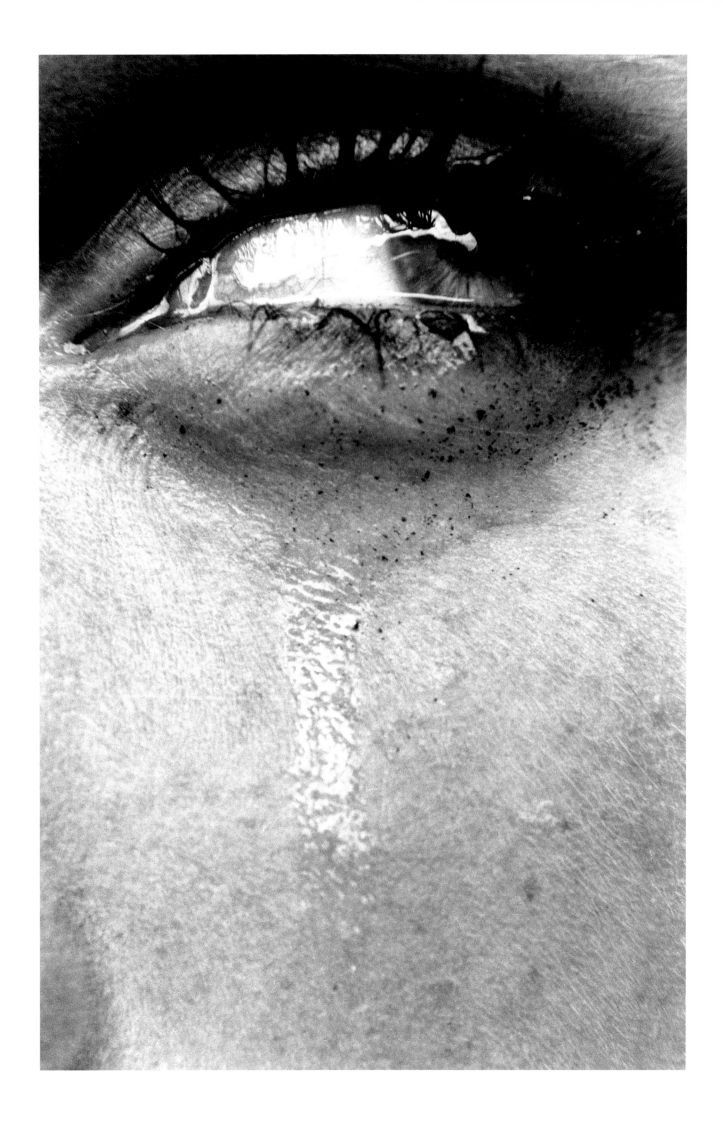

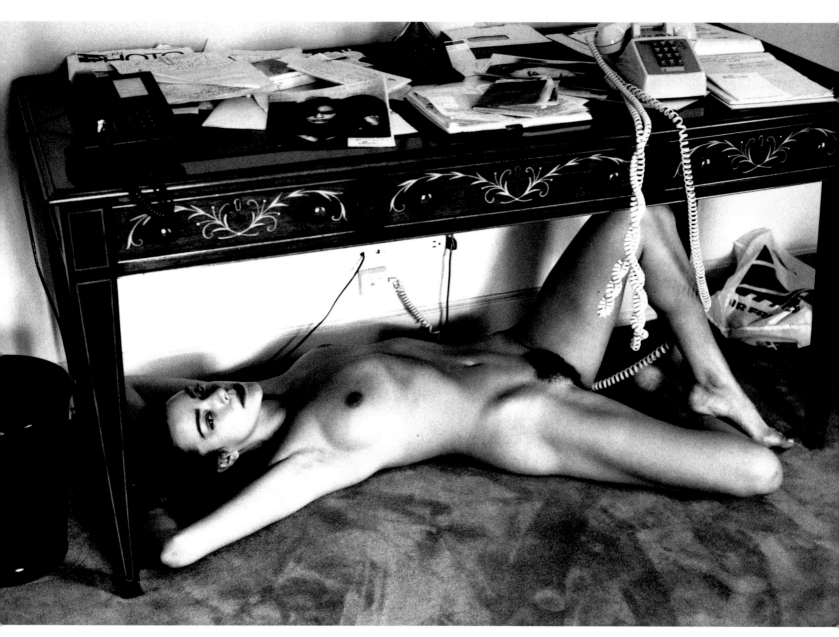

47 Domestic nude X – Young woman lying under my desk, Chateau Marmont, Hollywood 1992 ▲

46 Simonetta's eye, Bordighera, Italy 1982 ◄

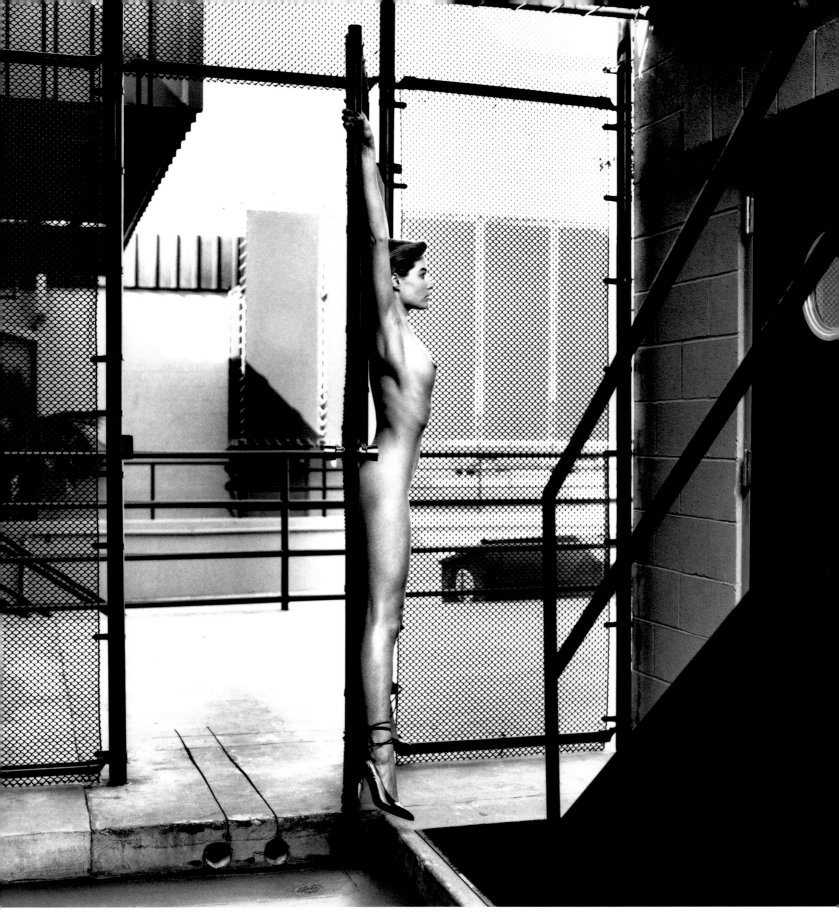

48 Young woman suspended, Los Angeles 1988 ▲

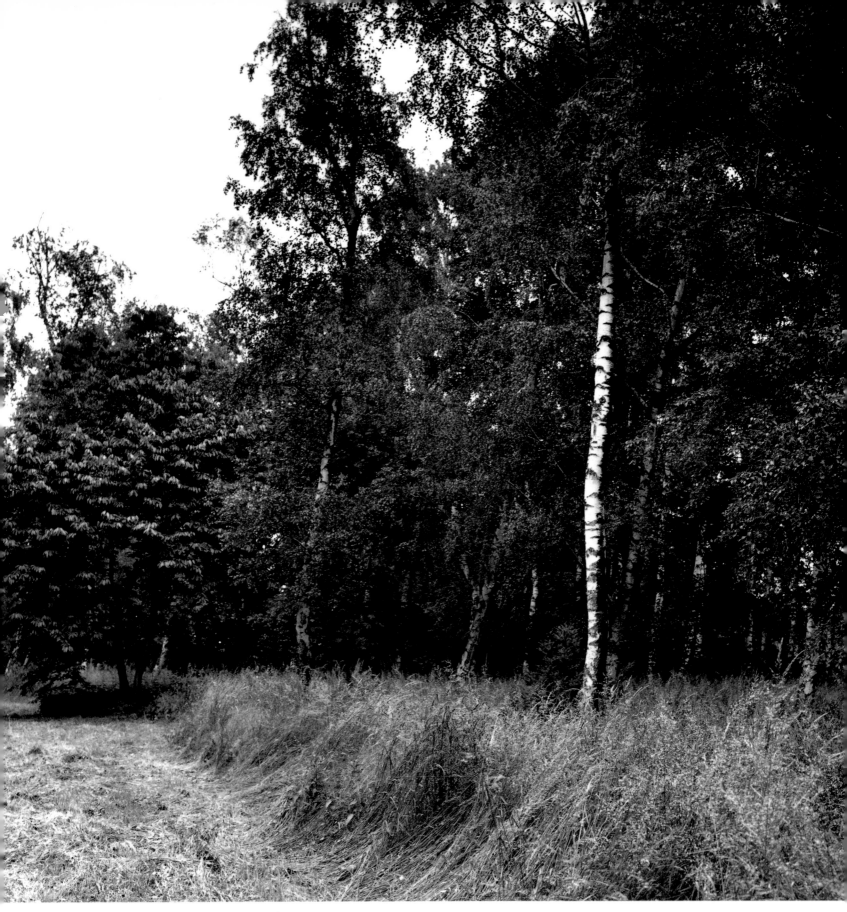

49 Birch tree, Vienna 1992 ▲

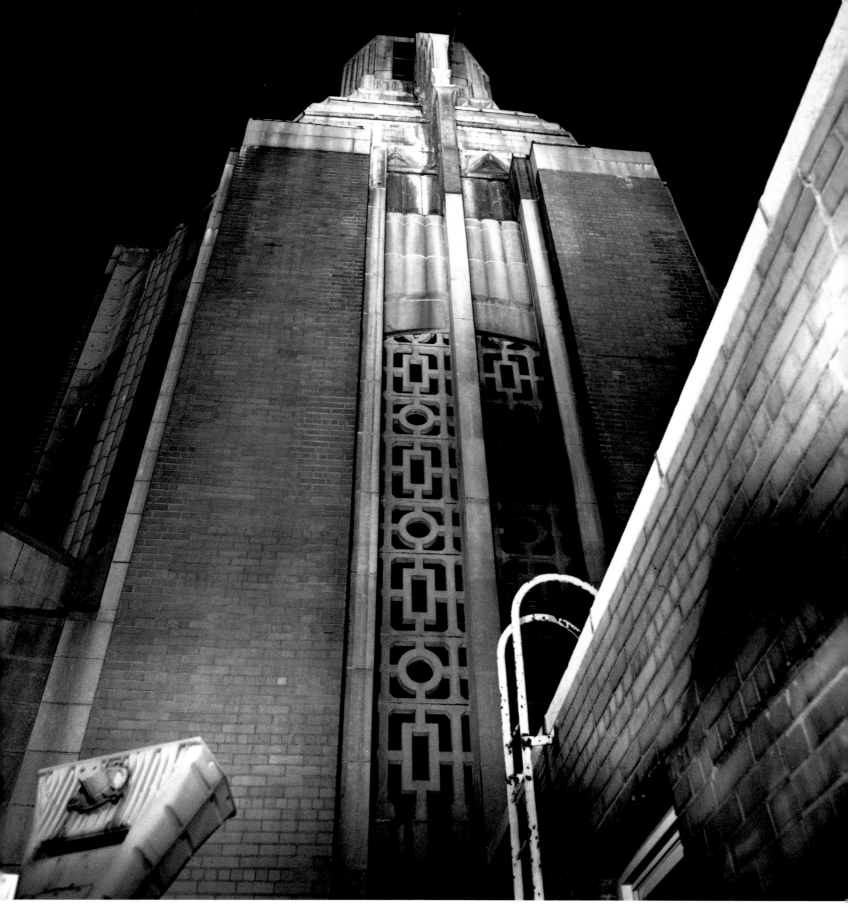

50 Waldorf Towers, New York 1990 ▲

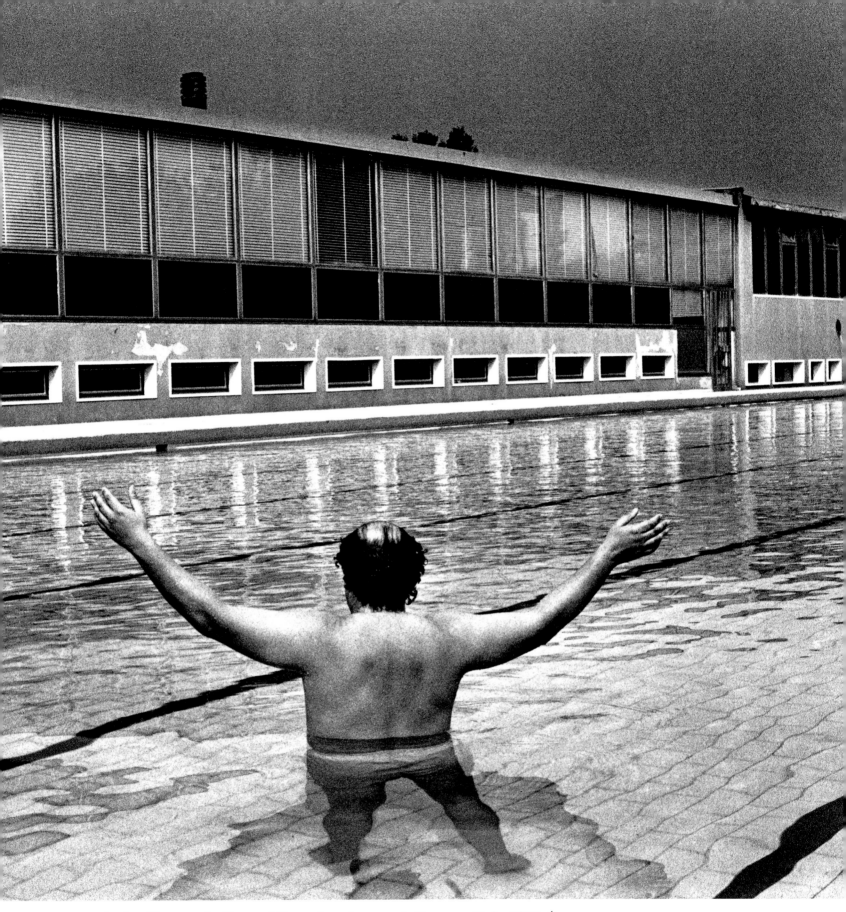

51 Xavier Moreau in the public swimming pool, Verona, Italy 1975 ▲

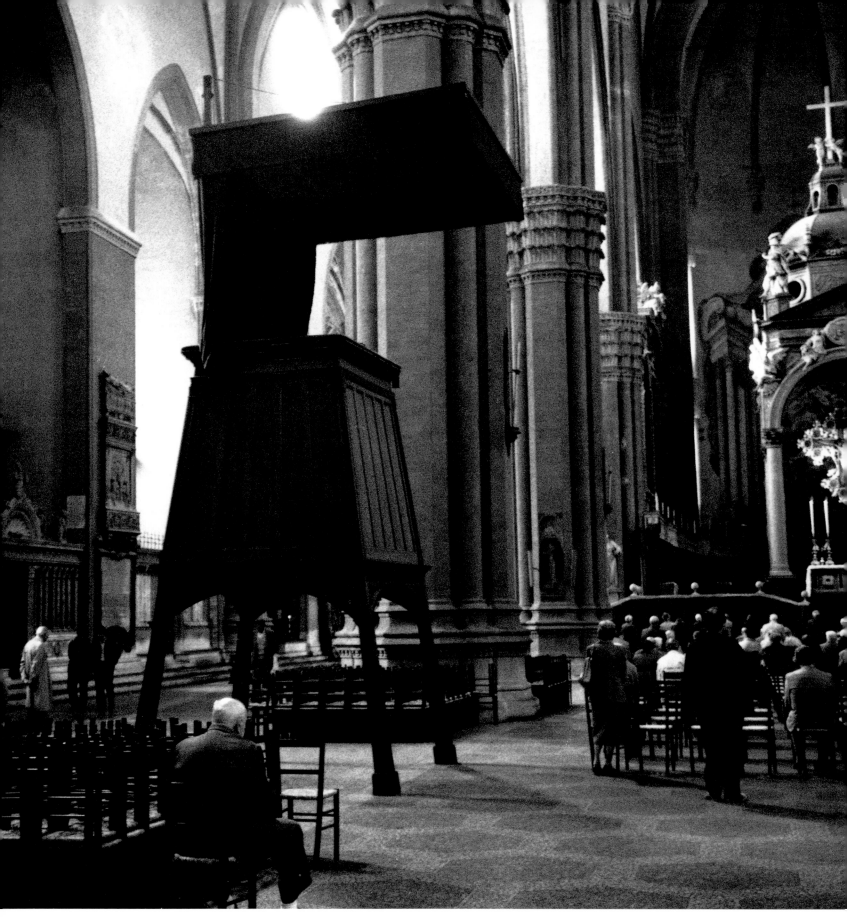

52 Bologna cathedral, Bologna, Italy 1990 ▲

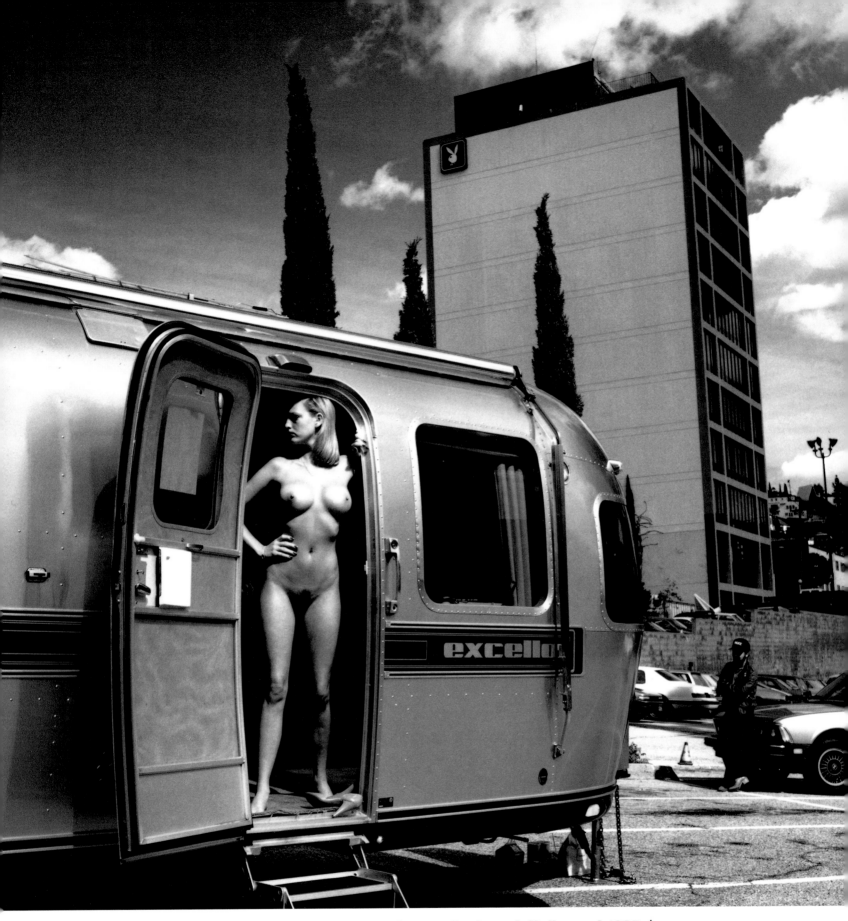

53 Domestic nude no. 0 in airstream trailer, Sunset Boulevard, Hollywood 1985 ▲

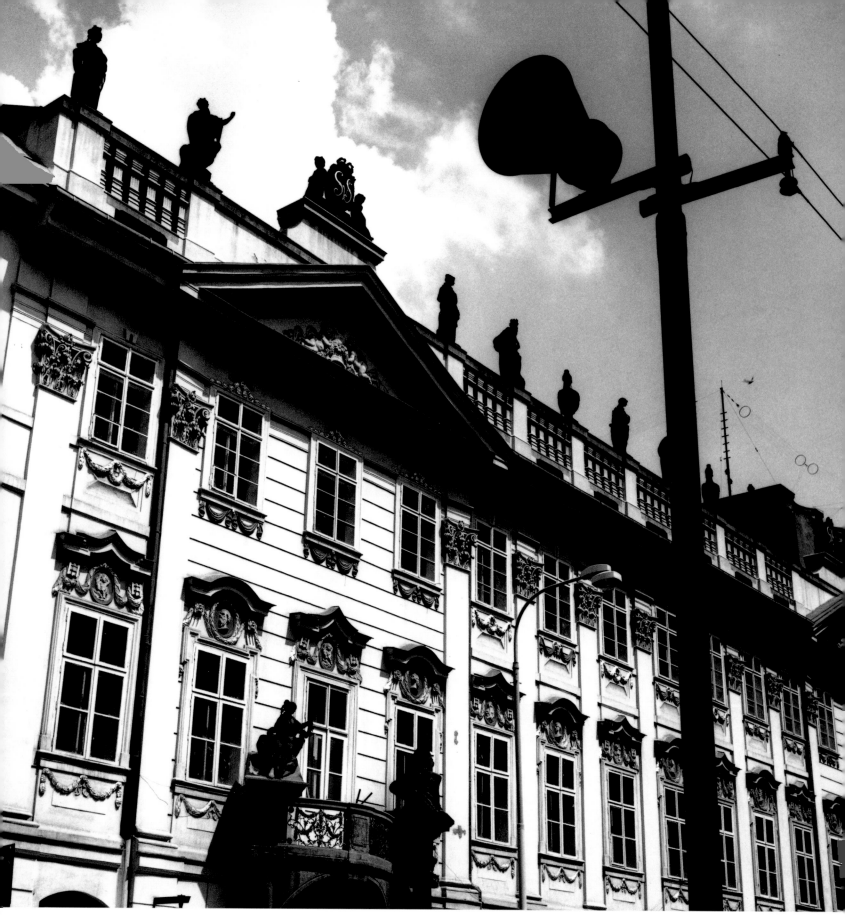

54 Prague 1988 ▲

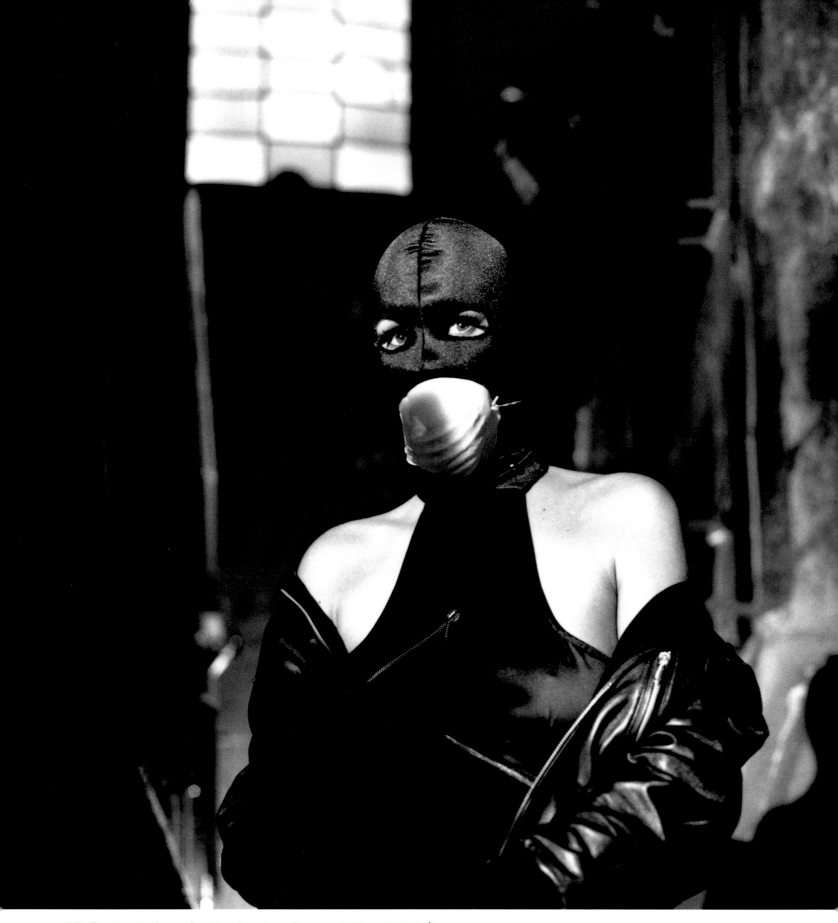

55 Protected against asbestos fumes, Milan 1988 ▲

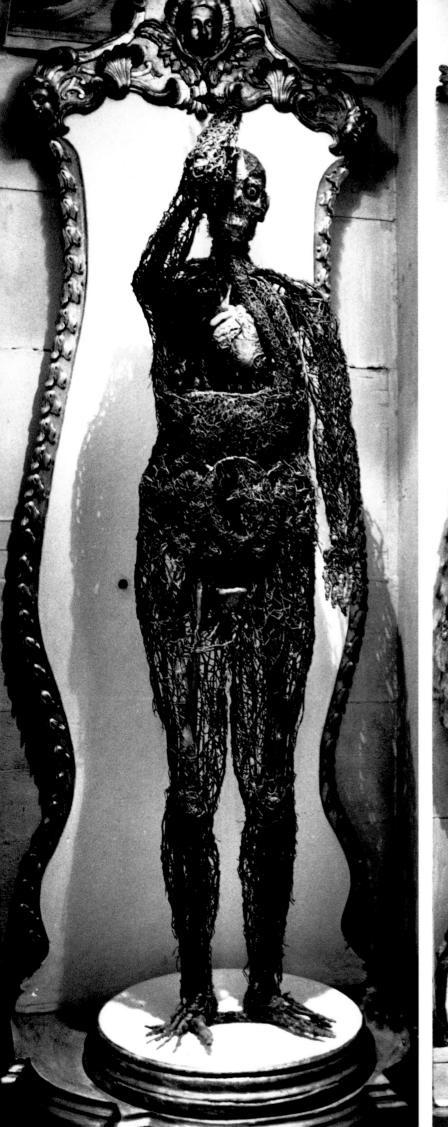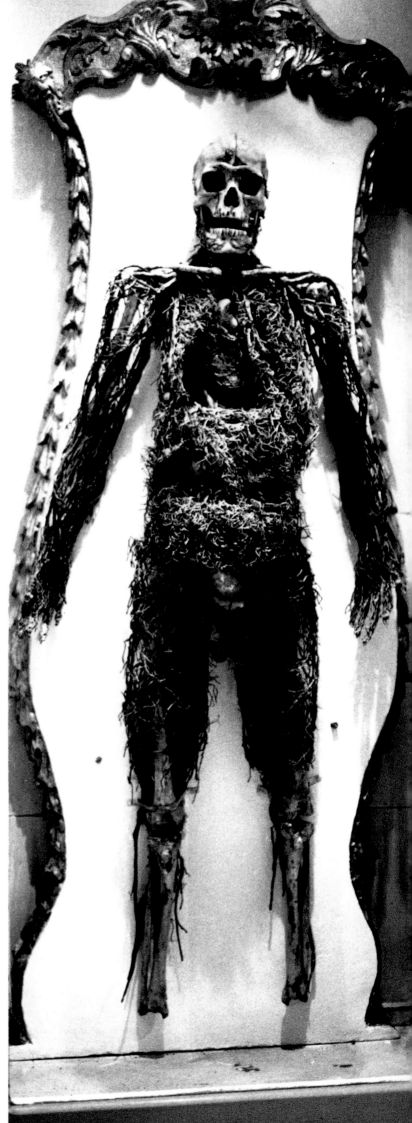

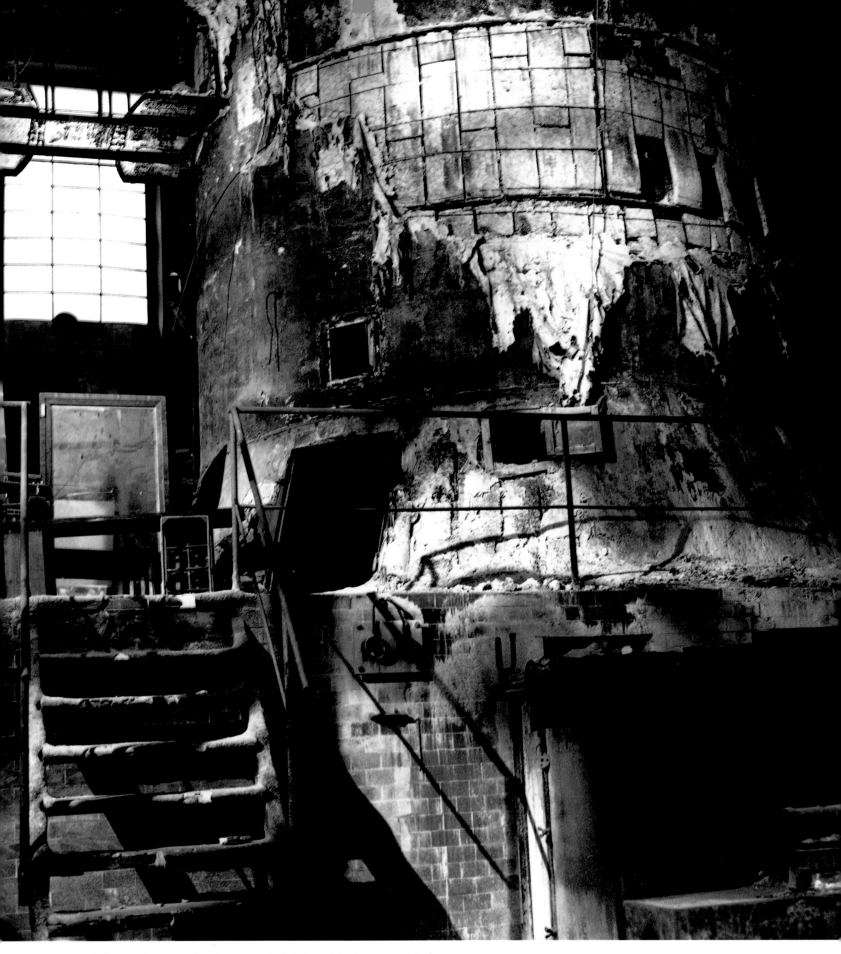

57 Disused soap factory, outskirts of Milan, 1984 ▲

56 Victims of the Prince of Sansevero, Naples 1990 ◀

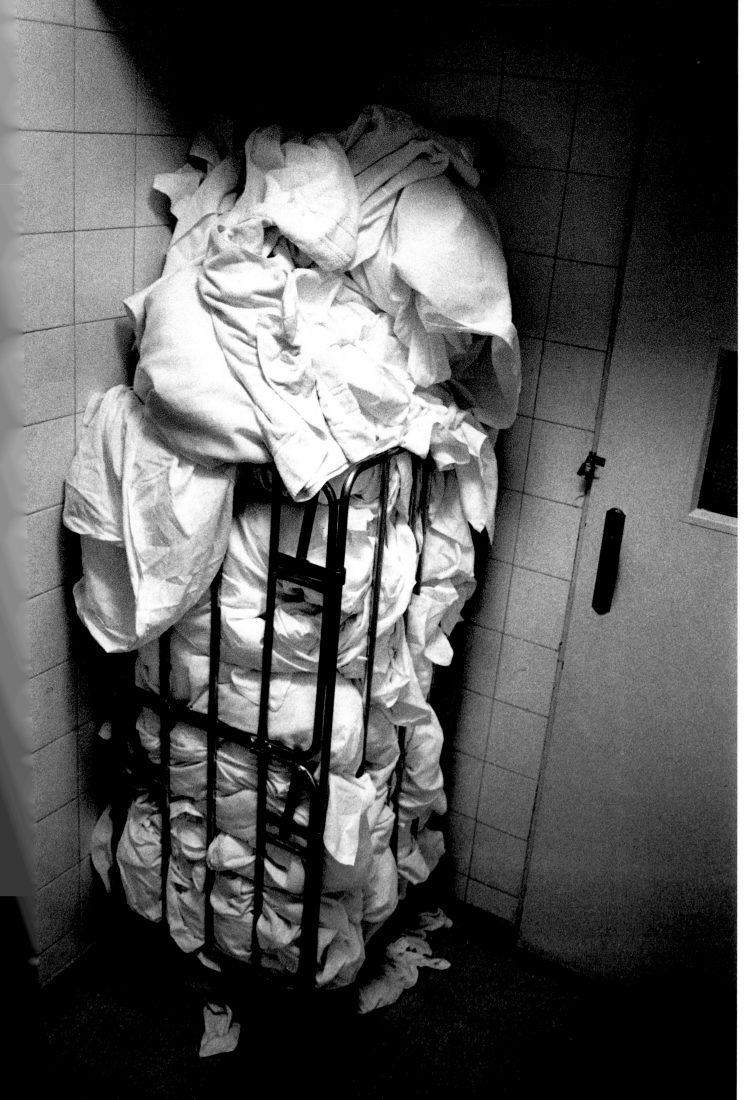

58 Laundry, backstairs at the Ritz, Madrid 1989 ▲

LIST OF PLATES

1 Canadair over 'La Vigie' and Monte Carlo Beach Hotel, 1985

2 Stone staircase by Otto Wagner, Vienna 1992

3 In Prof. Holubar's Josefinum I, Vienna 1992

4 Gary Oldman preparing the role of Dracula, Warner Bros. lot, Burbank 1992

5 In Prof. Holubar's Josefinum III, Vienna 1992

6 Parked car, Berlin 1988

7 In Prof. Holubar's Josefinum II, Vienna 1992

8 Swimming pool in James Mason's widow's house, Beverly Hills 1989

9 Young woman and Oceanographic Museum, Monaco 1988

10 Frau Sauer at the Nice Opera, 1991

11 Woman entering the 'Ennis-Brown House' by Frank Lloyd Wright, Los Angeles 1990

12 In the 'Fools' Tower', Vienna 1992

13 In my hotel suite, 1990

14 Men's room at Morton's Restaurant, Hollywood 1988

15 Domestic nude II – Waiting for the earthquake, Los Angeles 1992

16 Domestic nude I – In my kitchen, Chateau Marmont, Hollywood 1992

17 The Pacific at Venice, California 1990

18 Domestic nude IV – In my living room, Chateau Marmont, Hollywood 1992

19 Railroad siding of the 'Santa Fe' railroad, Omaha, Nebraska 1990

20 Domestic nude V – In my living room, Chateau Marmont, Hollywood 1992

21 June Resting, Hotel Volney, New York 1972

22 The sea at the heliport, Monaco 1992

23 On the Autobahn from Berlin, going east 1990

24 Arielle, Monte Carlo 1982

25 Reclining nude, Hollywood 1988

26 Dead mountain lion, California 1992

27 Arielle doing the backbend, Monte Carlo 1982

28 Waiting for Dracula II, Warner Bros. lot, Burbank 1992

29 Prague 1988

30 Arielle, Monte Carlo 1982

31 Omaha, Nebraska 1990

32 In the house of Mucha, Prague 1988

33 Domestic nude III – In the laundry room, Chateau Marmont, Hollywood 1992

34 Domestic nude VI and art dealer, Pacific Palisades, California 1992

35 Xavier Moreau, Washington 1985

36 Domestic nude IX – 'The Redhead', Los Angeles 1992

37 Domestic nude VIII – Plymouth and Old Plymouth, Los Angeles 1992

38 Domestic nude VII – in a playhouse, Los Angeles 1992

39 Young woman tied to my tree, Ramatuelle 1976

40 Bersaglieri holding Ferragamo shoes, Venice 1985

41 Butcher's shop window, Vienna 1991

42 Panoramic nude – 'Woman with gun', Grand Hotel Villa Serbelloni, Lake Como, 1989

43 Panoramic nude – 'The school teacher', Grand Hotel Villa Serbelloni, Lake Como 1989

44 Panoramic nude – 'With sunglasses and leather corset', Villa d'Este, Lake Como 1989

45 Panoramic nude – 'Backview', Villa d'Este, Lake Como 1989

46 Simonetta's eye, Bordighera, Italy 1982

47 Domestic nude X – Young woman lying under my desk, Chateau Marmont, Hollywood 1992

48 Young woman suspended, Los Angeles 1988

49 Birch tree, Vienna 1992

50 Waldorf Towers, New York 1990

51 Xavier Moreau in the public swimming pool, Verona, Italy 1975

52 Bologna cathedral, Bologna, Italy 1990

53 Domestic nude no. 0 in airstream trailer, Sunset Boulevard, Hollywood 1985

54 Prague 1988

55 Protected against asbestos fumes, Milan 1988

56 Left and right: Victims of the Prince of Sansevero, Naples 1990

57 Disused soap factory, outskirts of Milan, 1984

58 Laundry, backstairs at the Ritz, Madrid 1989

HELMUT NEWTON

BIOGRAPHY

Born in Berlin, 31 October 1920; has Australian nationality.
At sixteen, he begins an apprenticeship with the Berlin photographer Yva, celebrated for her fashion, portrait, and nude photography. From 1940 to 1944, he serves with the Australian army. In 1957, he settles in Paris.
During the 1960s and 1970s, he is a regular contributor to the French, American, Italian, and Britsh editions of *Vogue,* as well as *Elle, Marie-Claire, Jardin des modes, American Playboy, Nova, Queen,* and *Stern.*
Since 1981, he has lived in Monte Carlo.

1975 First one-man exhibition in the Galerie Nikon, Paris.
1976 Art Directors' Club, Tokyo, Prize for the best photography of the year.
1977–78 Prize of the American Institute of Graphic Arts for his first book, *White Women.*
1978–79 Gold Medal of the Art Directors' Club, Germany, for the best press photo.
1989 Awarded the title 'Chevalier des Arts et des Lettres' by the French Minister of Culture, Jack Lang.
 Awarded the 'Photographers' Prize for Outstanding Work and Contributions to Photography in the 1960s and 1970s' by the Photographic Society of Japan.
 Awarded the 'Grand Prix de la Ville de Paris' by the French Prime Minister, Jacques Chirac.
1990 Awarded the 'Grand Prix National de la Photographie' by Jack Lang.
1991 'World Image Award' for the best portrait photo, New York.
1992 Awarded the 'Grand Order of the Federal Republic of Germany'.

ONE-MAN EXHIBITIONS

1975 Galerie Nikon, Paris.
1976 Photographers' Gallery, London.
 Nicholas Wilder Gallery, Los Angeles.
1978 Marlborough Gallery, New York.

1979 American Center, Paris.
1980 G. Ray Hawkins Gallery, Los Angeles.
1981 Galerie Daniel Templon, Paris.
1982 Studio Marconi, Milan.
 Galerie Denis René – Hans Mayer, Düsseldorf.
 Marlborough Gallery, New York.
 Galerie Tanit, Munich.
 Galerie Photokina, Cologne.
1983 Gallery Asher-Faure, Los Angeles.
 G. Ray Hawkins Gallery, Los Angeles: 'Big Nudes'.
1984 Musée Chéret, Nice.
 Museo Palazzo Fortuny, Venice.
 G. Ray Hawkins Gallery, Los Angeles: 'Private Property'.
1984–85 Musée d'Art Moderne de la Ville de Paris, Paris: 'Retrospective'.
1985 G. Ray Hawkins Gallery, Los Angeles: 'New York'.
 Museo dell'Automobile, Turin: 'Retrospective'.
 Galerie Artis, Monte Carlo.
1986 Palais de l'Europe, Menton, France: 'Retrospective'.
 Foto Foundation, Amsterdam: 'Retrospective'.
1987 Rheinisches Landesmuseum, Bonn: 'Retrospective'.
 Galerie Daniel Templon, Paris: 'Nus inédits'.
 Groninger Museum, Groningen, Netherlands: 'Retrospective'.
 Galerie Daniel Templon, Paris: 'Nus inédits'.
 Groninger Museum, Groningen, Netherlands: 'Retrospective'.
1988 Museum des 20. Jahrhunderts, Vienna: 'Retrospective'.
 Forum Böttcherstrasse, Bremen: 'Retrospective'.
 Galerie Reckermann, Cologne: 'New Nudes'.
 Berlinische Galerie / Martin Gropius Bau, Berlin: 'Retrospective'.
 Hamilton Gallery, London: 'New Nudes'.
1988–89 Espace Photographique de Paris Audiovisuel, Paris: 'Nouvelles images'.
 National Portrait Gallery, London: 'Portraits Retrospective'.
1989 Metropolitan Teien Art Museum, Tokyo: 'Fashion Photographs and Portraits'.
 Seibu Art Museum, Funabashi, Japan: 'Fashion Photographs and Portraits'.

Fundación Caja de Pensiones, Madrid: 'Nuevas imagenes'.
State Pushkin Museum for Pictorial Art, and Pervaia Galereia, Moscow: 'Helmut Newton in Moscow'.
Prefectural Museum of Art, Fukuoka, Japan: 'Fashion Photographs and Portraits'.
Galleria d'Arte Moderna, Bologna: 'New Images'.
1989–90 Carlsberg Glyptotek, Copenhagen: 'New Images'.
1990 Kunstforum, Vienna.
Hochschule für Graphik und Buchkunst, Leipzig.
The Museum of Modern Art, Shiga, Japan: 'Fashion Photography and Portraits'.
1991 Biennale, Lyons.
Museum für Moderne Kunst, Bratislava.
Hamilton Gallery, London: 'Naked & Dressed'.
1992 Pascal de Sarthes Gallery, Los Angeles: 'Naked & Dressed in Hollywood'.
Goro International Exhibition, Tokyo: 'Helmut Newton'.
Crédit Foncier de France, Paris: 'Archives de Nuit'.

GROUP EXHIBITIONS

1975 Emily Lowe Gallery, New York: 'Fashion Photography, Six Decades'.
1977 International Museum of Photography, Rochester, N. Y.: 'The History of Fashion Photography'.
1978 Galerie Photokina, Cologne: 'Fashion Photography'.
1979 Galerie Zabriskie, Paris: 'French Fashion'.
1980 Galerie Zabriskie, Paris: '20/24 Polaroid'.
Centre Georges Pompidou, Paris: 'Instantanés'.
1981 Musée Rath, Geneva: 'Aspects de l'art d'aujourd'hui, 1970–1980'.
G. Ray Hawkins Gallery, Los Angeles: 'Hans Bellmer, Helmut Newton, Alice Springs'.
1982 Musée Jacquemart-André, Paris, and Galerie Photokina, Cologne: '50 années de photographie de Vogue Paris'.
1985 Victoria and Albert Museum, London: 'Shots of Style'.
1986 Palais de l'Europe, Menton, France: 'La femme sur la plage'.
1988 Musée de la Mode, Paris: 'Splendeurs et misères du corps'.
Musée d'Art Moderne, Paris: 'Splendeurs et misères du corps'.
Triennale Fribourg: 'Splendeurs et misères du corps'.
Royal Academy of Arts, London: 'The Art of Photography'.
1989 Museum of Fine Arts, Houston: 'The Art of Photography'.
USSR Ministry of Culture, Moscow.
Kunstforum, Vienna.
1991 Victoria and Albert Museum, London: 'Appearances'.

PUBLIC COLLECTIONS

American Friends of the Israel Museum, Jerusalem.
Baltimore Museum of Art, Maryland.
Berlinische Galerie / Martin Gropius Bau, Berlin.
Brandeis University, Waltham, Massachusetts.
Bucknell University, Lewisburg, Pennsylvania.
Chamber Opera Theater, New York.
College of Holy Cross, Worcester, Massachusetts.
College of William and Mary, Williamsburg, Virginia.
Corcoran Gallery of Art, Washington, D. C.
Fashion Institute of Technology, New York.
Fonds Régional d'Art Contemporain, Bordeaux.
Haus der Deutschen Geschichte, Berlin.
Michigan University, Dearborn, Michigan.
Michigan State University, East Lansing, Michigan.
Musée d'Art Moderne, Saint-Etienne.
Musée d'Art Moderne de la Ville de Paris.
Musée des Beaux-Arts, Jules Chéret, Nice.
Musée Départemental des Vosges, Epinal.
National Portrait Gallery, London.
Ohio Wesleyan University, Delaware, Ohio.
Paris Audiovisuel, Ville de Paris.
Rheinisches Landesmuseum, Bonn.
San Francisco Museum of Art.
State University of New York at Albany, N. Y.
University of Pennsylvania, Philadelphia.
University of Wisconsin, Milwaukee.
Victoria and Albert Museum, London.

BOOKS AND EXHIBITION CATALOGUES

1976 *White Women*. Preface by Philippe Garner. Editions Filipacchi, Paris.
American edition: Congreve, New York.
British edition: Quartet Books, London.
German edition: Schirmer / Mosel, Munich.
1978 *Sleepless Nights*. Preface by Edward Behr. Editions Filipacchi, Paris.
American edition: Congreve, New York.
British edition: Quartet Books, London.
German edition: Schirmer / Mosel, Munich.
1979 *24 Photos Lithos. Special Collection*. Preface by Brian Gysin. Editions Filipacchi, Paris.
American edition: Congreve, New York.
British edition: Quartet Books, London.
German edition: Rogner & Bernhard, Munich.
1981 *Big Nudes*. Preface by Bernhard Lamarche-Vadel (French / English). Editions du Regard, Paris.
1982 *Helmut Newton – 47 Nudes*. Preface by Karl Lagerfeld. Thames and Hudson, London.
1983 *White Women*. Japanese edition: Kadansha, Tokyo.
1984 *World Without Men*. Texts by Helmut Newton. French, American, British, and German editions: Xavier Moreau, New York.
Helmut Newton – Portraits. Preface by Françoise Marquet. Exhibition catalogue, Musée d'Art Moderne de la Ville de Paris.
Big Nudes. Preface by Karl Lagerfeld. Second and

third American editions: Xavier Moreau, New York.

1986 *Helmut Newton. Portraits.* Exhibition catalogue, Foto Foundation, Amsterdam.
Helmut Newton – Portraits. Preface by Carol Squires.
American edition: Pantheon, New York.
French edition: Nathan, Paris.
German edition (with preface by Klaus Honnef): Schirmer / Mosel, Munich.
British edition: Quartet Books, London.
Helmut Newton. 'Photo-poche' series. Centre National de la Photographie, Paris.

1987 *Helmut Newton's Illustrated No. 1: Sex and Power.* Xavier Moreau, New York.
Helmut Newton's Illustrated No. 2: Pictures from an Exhibition. Schirmer / Mosel, Munich.
Helmut Newton – Portraits. Preface by Klaus Honnef. Second edition: Schirmer / Mosel, Munich.

1988 *Helmut Newton – Nouvelles Images.* Preface by Henri Chapier. Exhibition catalogue, Espace Photographique de Paris, Paris Audiovisuel.
Helmut Newton – Portraits. Exhibition catalogue, National Portrait Gallery, London; Schirmer / Mosel, Munich.

1989 *Helmut Newton – Portraits.* Texts by Klaus Honnef, Helmut Newton, and Ikura Takano. Exhibition catalogue, Metropolitan Teien Art Museum, Tokyo.
Helmut Newton – Imagenes. Exhibition catalogue, Fundación Caja de Pensiones, Madrid.
Helmut Newton – Private Property. Text by Marshall Blonsky. Schirmer / Mosel, Munich.
Helmut Newton – New Images. Texts by Ennery Taramelli and Laura Leonelli. Exhibition catalogue, Galleria d'Arte Moderna, Bologna.
Helmut Newton in Moscow. Exhibition catalogue, State Pushkin Museum, Pervaia Galereia and Dekotarivnoie Iskusstvo, Moscow.

1990 *Das Glas im Kopf wird vom Glas...* Text by Jan Fabre. Imschoot Uitgevers, Belgium, in association with the exhibition 'The Dance Sections' in the Théâtre de la Ville, Paris.
Big Nudes. Preface by Karl Lagerfeld. Sixth edition; German, French, and English editions: Schirmer / Mosel, Munich.

1991 *Sleepless Nights.* Third edition: Schirmer / Mosel, Munich.
Helmut Newton's Illustrated No. 3: I Was There. Schirmer / Mosel, Munich.

1992 *Eroticism in the 20th Century.* Exhibition catalogue, Goethe Institute, Tokyo, and Photographic Society of Japan (eds.), Tokyo and Fukuoka.
Naked and Dressed in Hollywood. Preface by Jan van der Marek. Exhibition catalogue, Pascal de Sarthe Gallery, Los Angeles.
White Women. Fifth edition: Schirmer / Mosel, Munich.
Pola Woman. Preface by Helmut Newton. German, French, and English edition: Schirmer / Mosel, Munich.
Archives de nuit. Preface by José Alvarez. Exhibition catalogue, Crédit Foncier de France, Paris. German and English edition: Schirmer / Mosel, Munich.

FILMS ABOUT HELMUT NEWTON

1978 *Helmut Newton.* Television documentary by Michael White. Thames Television, London. 55 min.

1988 *Frames from the Edge.* Television documentary by Adrian Maben. R. M. Productions. 90 min. (Video cassettes with the American and Spanish versions; French and German versions in preparation.)

1992 *The Originals.* Television documentary. Sleeping Giant Productions.

This publication accompanies an exhibition of mostly
unpublished photographs by Helmut Newton, entitled
'Archives de nuit', shown from 20 November–19 December
1992 in the galleries of the Crédit Foncier de France, Place
Vendôme, Paris. The exhibition is currently on tour
throughout Europe.

Exhibition Director: Claude Geiss
Publication design and production: June Newton

The introduction by José Alvarez was translated from French
by Michael Robertson.

Schirmer Art Books is an imprint of Schirmer/Mosel Verlag
GmbH, Munich
For trade information please contact:
Schirmer Art Books, 112 Sydney Road, Muswell Hill, London
N 10 2 RN, England or
Schirmer/Mosel Verlag, P. O. Box 401723,
8000 München 40, Germany
Fax 089/338695

A CIP catalogue record for this book is available from the
British Library.

Lithos: O. R. T. Kirchner GmbH, Berlin
Typesetting: Typ-O-Graph, Munich
Printing: Passavia, Passau

ISBN 3-88814-664-X

A Schirmer/Mosel production